IMAGES
of America

CUYAHOGA COUNTY
THE FIRST 200 YEARS

ON THE COVER: Built between 1825 and 1832, the Ohio and Erie Canal, linking Lake Erie at Cleveland with the Ohio River at Portsmouth, was constructed by the state to contribute to the economic prosperity of Ohio. The cover photograph, dated 1896, depicts the canal at Stone Road, south of Cleveland, and a canal boat then in use. The cabin visible at the rear is described as a fur trader's shelter, which was built when the canal was constructed. (Cleveland Public Library Photograph Collection.)

IMAGES
of America

CUYAHOGA COUNTY
THE FIRST 200 YEARS

Judith G. Cetina, Ph.D., in association
with the Cuyahoga County Archives

ARCADIA
PUBLISHING

Published by Arcadia Publishing
Charleston, South Carolina

Printed in the United States of America

Library of Congress Control Number: 2010939830

For all general information, please contact Arcadia Publishing:
Telephone 843-853-2070
Fax 843-853-0044
E-mail sales@arcadiapublishing.com
For customer service and orders:
Toll-Free 1-888-313-2665

Visit us on the Internet at www.arcadiapublishing.com

*To my late parents, Bernice and Edward, who instilled in
me a love of place and an abiding passion for history.*

CONTENTS

Acknowledgments 6

Introduction 7

1. Cuyahoga County: The Prequel 9

2. The Early Years: 1810–1830 17

3. An Age of Development and Reform: 1830–1859 23

4. A Time for War and a New Beginning: 1860–1899 29

5. War and Peace: 1900–1919 47

6. Boom and Bust: 1920–1929 59

7. An Odd Couple of Depression and Hope: 1930–1939 69

8. Entering a New Age: 1940 to the Present 97

ACKNOWLEDGMENTS

Cuyahoga County recently concluded its birthday celebration, which took place between 2008 and 2010, and it was in the deliberations of the Bicentennial Advisory Committee that the idea for a book first took form. With the encouragement of Arcadia Publishing, I developed a proposal for the publication, and thanks to the invaluable guidance of editors Melissa Basilone and John Pearson, *Cuyahoga County: The First 200 Years* is now a reality. I extend my deepest thanks and personal gratitude to Margaret Baughman, the photograph librarian for the Cleveland Public Library Photograph Collection, for her assistance in identifying images and facilitating the use of all these remarkable photographs for the book. I also extend my appreciation to Patrice Hamiter and Danilo Milich, staff members of the Cleveland Public Library Photograph Collection, for their singular help with my project. Thanks are also due to Thomas B. Edwards, the map librarian of the Cleveland Public Library; William Barrow, the special collections librarian, and Vern Morrison, a member of the Digital Production Unit of Michael Schwartz Library, Cleveland State University Library; Kara Hamley O'Donnell, the historic preservation planner for the City of Cleveland Heights; and Jill Tatem, university archivist, Case Western Reserve University. I am also grateful to Matthew Black, Maureen Pergola, Rhonda Smith, and Lenay Stevers, all members of the Cuyahoga County Archives staff; John Myers, the real estate manager for Cuyahoga County, who oversees the archives; Dr. Gladys Haddad, professor of American Studies, Case Western Reserve University; and Dr. Marian Morton, professor emeritus, John Carroll University. Special appreciation is extended to Rhonda Smith for her valued technical assistance. My gratitude is also expressed to Tim Daley, executive director of the Soldiers and Sailors Monument, and Rose Costanzo, who shared photographs and images from their personal collections.

Unless otherwise noted, all images appear courtesy of the Cleveland Public Library Photograph Collection.

INTRODUCTION

Cuyahoga County totals 458.3 square miles in size and is bordered by Lake Erie to the north, Geauga and Lake Counties to the east, Lorain County to the west, and Medina and Summit Counties to the south. If asked to characterize this county of northern Ohio, most residents would note its reputation as a center for corporate and manufacturing interests and as a home for multiple institutions of higher learning, numerous cultural treasures, sports dynasties, and renowned medical facilities. Images of Terminal Tower, Cleveland Browns Stadium, Progressive Field, and Quicken Loans Arena would likely come to mind, along with Severance Hall, the Cleveland Museum of Art, the Cleveland Playhouse, and the Rock and Roll Hall of Fame. The names of the county's prominent sons and daughters might also be recalled, including Kaye Ballard, Drew Carey, Tim Conway, Phil Donahue, Margaret Hamilton, Paul Newman, Jesse Owens (moved to Cleveland as a child), and British-born, but Cleveland-raised, Bob Hope. Others might think of opportunities for recreational activities, including visits to the Cleveland Metroparks Zoo, boating on Lake Erie, or biking through the metroparks. Or perhaps some might remember a night out in the Warehouse District or on East Fourth Street.

But beyond the city of Cleveland—Cuyahoga's county seat—58 other municipalities, villages, and townships in the county beckon to the visitor or perspective resident, offering tree-lined streets and homes that represent architectural styles ranging from Colonial to Tudor and Queen Anne to Victorian. Quiet town squares coexist with bustling commercial areas, and the landscape is dotted with hills and valleys, creeks and streams, falls and dams, parks and playgrounds, and hiking trails and residential sidewalks. All within the space of a day, one can travel from Lakewood Park to Cain Park in Cleveland Heights or perhaps tranquil Chagrin Falls and back to Huntington Beach in Bay Village or the county fairgrounds in Berea. And a journey throughout the county would not be complete without a tour of the many memorable ethnic neighborhoods noted for their magnificent churches, delicious food, and lively music, from Little Italy to Tremont and from Collinwood to Slavic Village. African Americans have also played an important role in the development of the county with their historical contributions preserved in collections at area institutions like the Western Reserve Historical Society. But where one now sees vital urban and suburban areas that blend ethnic, religious, cultural, and racial diversity, it is difficult to imagine its roots as a place of settlement for earlier civilizations dating to 2000 BCE. Excavations demonstrate that civilizations, like the Adena and Hopewell Mound Builders, flourished from about 800 BCE to 1000 CE in what is now Cuyahoga County. Considerably later Native American groups, including the Shawnees, Miamis, and Delawares, also made this area their home.

But centuries passed before Ohio became the 17th state to join the Union in 1803. It would take another five years until the Ohio General Assembly approved a statute dated February 10, 1808. This proclaimed that the part of Geauga County "[that] lies west of the ninth range of townships" would become a separate and distinct entity to be known by the name of Cuyahoga, which would be organized whenever the population was sufficient to require it. Another two years would pass before Cuyahoga County was formally separated from Geauga and declared to be independent, effective May 1, 1810.

In 2011, it is clear that the county has indeed come a long way from frontier outpost to modern urban community. Its population has soared from an initial settlement of 1,459 in 1810 to 1,393,845 according to the 2000 census. While Cleveland remains the dominant municipality at 477,459, nine other cities have populations over 25,000, with Parma, the largest, at over 85,000 and Lakewood, Euclid, and Cleveland Heights each with over 50,000 persons. The population is many and varied with 34.1 percent declared minorities, including African American, Hispanic, Native American, and Asian residents, living in Cuyahoga County's culturally rich and racially, ethnically, and religiously diverse communities.

The county's workforce is active in a variety of areas, being employed in trade; manufacturing; transportation and utilities; construction; agriculture, forestry, and fishing; government; mining; finance; and the services industry, the largest, claiming the 32.6 percent of workers. Among the county's major employers in 2000 were American Greetings, Case Western Reserve University, and the Cleveland Clinic Health System, with the University Hospitals Health System ranked in the top 15. The county's high standing in the medical field can be attested to by its 5,949 physicians (medical doctors and doctors of osteopathy) and 23 registered hospitals in the year 2000.

But the county's history is yet being written. Cuyahoga County remains well aware of its rich past rooted in Native American settlement, New England virtues and values, the rich traditions of ethnic communities, and the contributions of its heroic, generous, inventive, and talented citizens. And the area's large number of historical societies, archival facilities, and museums preserves its heritage. But the county's residents and leadership are forever looking forward with hope, confidence, and enthusiasm to a future filled with promise; one that will be marked by the increased use of wind energy, an enlivened lakefront, and an area that continues to offer world-class medical care.

One

CUYAHOGA COUNTY
THE PREQUEL

The story of Cuyahoga County officially began in 1808 with legislation that enabled its creation and later made possible its full establishment in 1810. It is easy to imagine that the land the county encompassed stood barren, undiscovered, and unoccupied prior to the 19th century. This chapter will dispel that myth and illustrate the evolution the area experienced from the dwelling place of Native Americans who called the area Cuyahoga, which was a term that denoted crooked river, to a beckoning frontier attracting settlers of the newly formed United States seeking new opportunities and a better life. The lands constituting Cuyahoga County were also subject to international interests as Spain, France, and England, at various time prior to the Revolution, staked a claim to this territory. In 1783, England surrendered all title to the Thirteen Colonies, and Connecticut finally yielded its claims in 1786 but reserved the territory that would be known as the Connecticut Western Reserve. It consisted of 3.3 million acres and extended 120 miles west from the Pennsylvania border and some 70 miles south from Lake Erie. A section of the Western Reserve would eventually become Cuyahoga County, but over 20 years passed before this became a reality. The entire Ohio country was part of the Northwest Territory, established by the ordinance of 1787, and governed by General St. Clair. In 1788, the land east of the Cuyahoga River was designated as Washington County, and the land west of the River was named Wayne County, with Detroit as its seat. More changes would follow, and in 1800 the lands east and west of the Cuyahoga River were joined in the creation of Trumbull County. Its boundaries coincided with those of the Western Reserve. Geauga County was created from the existing Trumbull County in 1806, and finally in 1808 Cuyahoga County was established, along with Ashtabula and Portage, being carved from parent counties of Geauga and Trumbull. But the past would only serve as the prelude for the development of this fledgling county, and its future began with the first county commissioners' meeting held on June 6, 1810.

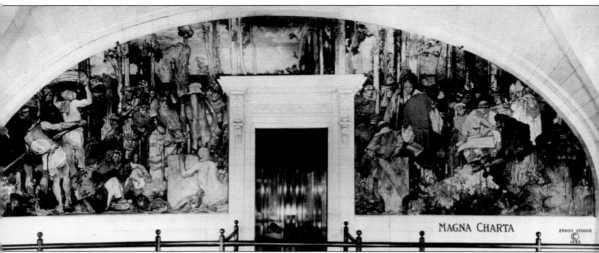

MAGNA CHARTA

The Magna Carta, an English charter, granted to all freemen the rights and liberties it encompassed. On June 15, 1215, King John met with his barons and knights who had forced the monarch to confirm their liberties or suffer the consequences of war to the death. The Barons had submitted to John their demands some months before, and on June 15 the king affixed his seal to the preliminary draft. After fours days of negotiation regarding the particulars, John would place the great seal on all of the copies. Some have referred to the Magna Carta as the "Mother of all Constitutions," and this document had a decided influence on those who drafted the Constitution of the United States. Sir Frank Brangwyn's 1913 painting, *King John Signing the Magna Carta at Runnymede*, hangs at the entrance to the courtroom for the Court of Appeals at the Cuyahoga County Courthouse on Lakeside Avenue.

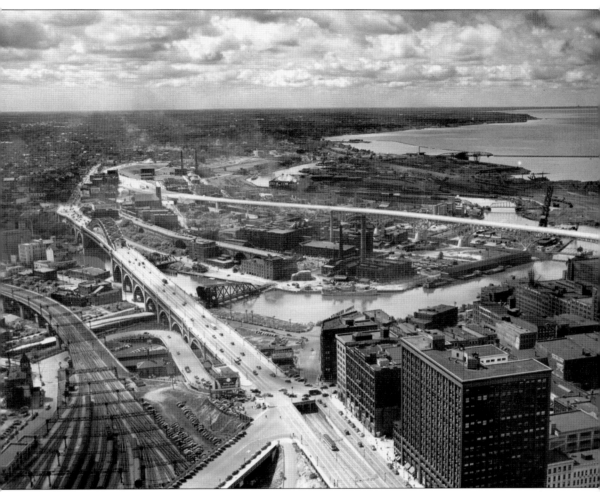

Cuyahoga County's destiny was shaped by its location on the shores of Lake Erie and the banks of the Cuyahoga River. One of the five Great Lakes, Erie is the fourth largest and ranks among the top 20 in the world by surface area. Lake Erie's waters have nurtured the growth of Cleveland and Cuyahoga County, from the city of Euclid westward to Bay Village, facilitating agricultural growth, manufacturing, popular recreation, trade, transportation, and energy production. The Cuyahoga River, the lifeblood of the county, flows south and north over a 100-mile course and derives its name from a combination of Native American references commonly translated as "crooked river." This view depicts both bodies of water, and one can also observe the Veterans Memorial and the Main Avenue Bridges, two of the spans that cross the Cuyahoga River and link the east and west parts of the county.

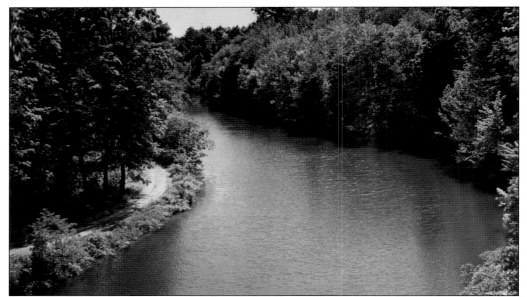

"This is the forest primeval," Henry Longfellow's opening to the poem "Evangeline," calls to mind this view of the Rocky River, perhaps as first glimpsed by the Native Americans who settled in Cuyahoga County. The Rocky River creates the western boundaries of the cities of Cleveland and Lakewood, flowing north to Lake Erie, and carves the river valley that cradles the Rocky River Reservation, one of the Cleveland Metroparks. The plentiful trees add to the reservation's characterization as a wilderness.

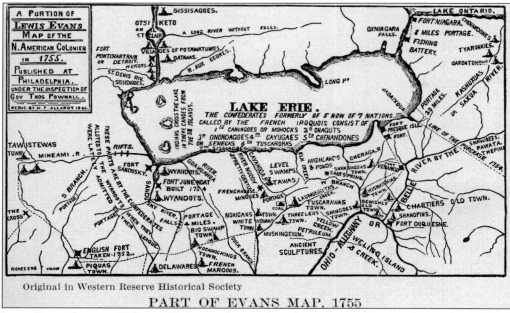

Lewis Evans, born in Wales in 1700, served as a colonial surveyor and geographer and completed assignments for Benjamin Franklin. This portion of Evans's 1755 map of the North American Colonies clearly identifies the Cayahoga (Cuyahoga) River and the names of those Native American groups that comprised the seven nations. (Courtesy of Cleveland State University.)

Charles Yardley Turner's painting, *The Conclave Between Pontiac and Rogers' Rangers at the Cuyahoga River, November 1760,* hangs in the Court of Appeals courtroom in the county courthouse. It commemorates the historic meeting between Rogers and Pontiac, the ally of the French and the chief of the Ottawas, during the French and Indian War. Pontiac agreed to be at peace with the English provided they paid him due deference.

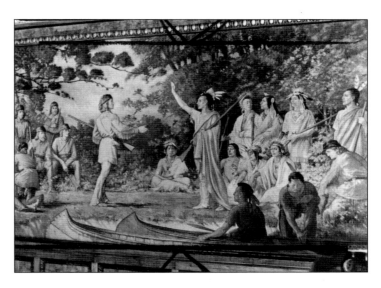

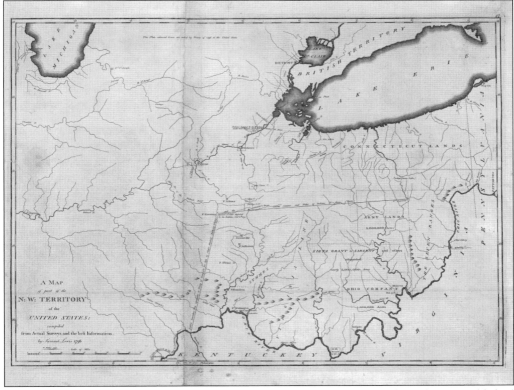

Cuyahoga County was once contained within the Northwest Territory, the latter being established in 1787. Samuel Lewis, an early map publisher of the 19th century, compiled the map. He drew upon existing surveys and the "best information." This illustration of the Northwest Territory identifies both the Cuyahoga River and the Rocky River. (Courtesy of the Cleveland Public Library Map Collection.)

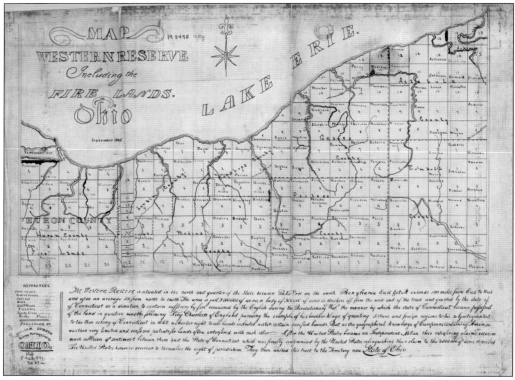

Cuyahoga County was created from land in northeast Ohio that was reserved by the State of Connecticut, the latter ceding its other claims in the Ohio country to the federal government. Known as the Western Reserve, this eastern part of the territory owned by the State of Connecticut was sold to the Connecticut Land Company in 1795. This map, dated 1823, depicts the Western Reserve, including Cuyahoga County and its several townships. (Courtesy of the Cleveland Public Library Map Collection.)

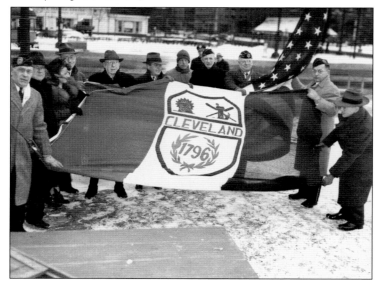

The history of Cleveland is integral to the story of Cuyahoga County. Cleveland's history was marked in 1946 with the celebration of the 150th anniversary of Moses Cleaveland's landing at the mouth of the Cuyahoga River. Those identified in the flag raising include, from left to right, Marguerite Bacon, Laurence N. Orton, Charles Otis, and Mayor Thomas A. Burke; the others are not identified.

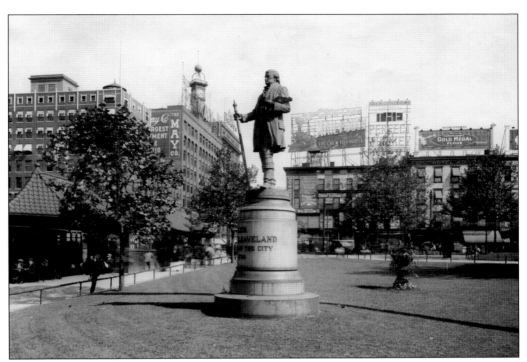

The statue of Moses Cleaveland, sculpted by James C. Hamilton and cast in bronze, was erected by the Early Settlers Association of the Western Reserve in 1888 in commemoration of the 92nd anniversary of the city's establishment. Cleaveland's statute stands on the southwest quadrant of Public Square and displays the founder as a surveyor, carrying the staff of Jacob in his right hand and a holding a compass in his left hand.

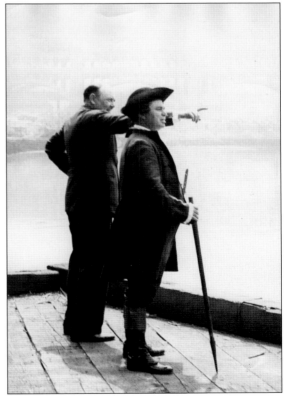

The historic landing of Moses Cleaveland was reenacted during the city's sesquicentennial celebration in 1946, and this view shows Cuyahoga County engineer John O. McWilliams extending his hand in apparent conversation with an unidentified gentlemen portraying Moses Cleaveland. The photograph symbolizes the promise of the future as envisioned by Cleaveland and realized in the achievements of the city 150 years later. (Courtesy of the Cuyahoga County Archives and the Cuyahoga County Engineer's Office.)

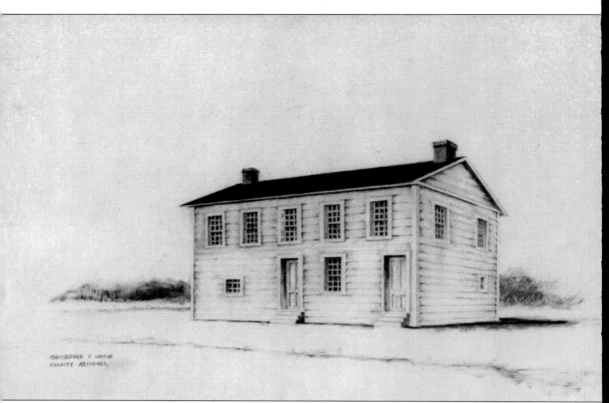

The first Cuyahoga County Courthouse served as the initial seat of Cuyahoga County government, and Levi Johnson, under a contract with the county commissioners, built it in 1812–1813. Standing on the northwest corner of Public Square, the structure, covered by clapboard, was painted red with white window frames and was approximately 20-by-50 feet and two stories high. A two-cell jail occupied half of the lower floor, and accommodations for the jailor were available adjacent to the cells. There was a single large hall on the second floor that was used for social events, town meetings, talks, religious services, and, on occasion, court proceedings. The simplicity of the courthouse reflected its impermanent nature, as Newburgh contested Cleveland's designation as the county seat, a disagreement not settled until 1826. The second county courthouse would succeed it in 1828. (Courtesy of the Cuyahoga County Archives.)

Two

THE EARLY YEARS
1810–1830

Designated by the constitution of Ohio and through other legislation, the commissioners, the sheriff, and the coroner were the first elected county officers, while the treasurer, judges of the common pleas court, surveyor, prosecutor, recorder, and clerk of courts were appointed. The first meeting of the Cuyahoga County Commissioners was held on June 6, 1810, and one of the initial orders issued by commissioners Jabez Wright and Nathaniel Doan was the payment of $1 for wolf scalps for "the year ensuing." The Common Pleas Court held its inaugural session in a newly completed frame-store building situated on the south side of Superior Avenue between Public Square and Seneca Street, now West Third Street. But within two years, the county contracted to construct a courthouse and jail on the northwest quadrant of the square. The project began in 1812, and the building was completed in the summer of 1813.

Yet the future of the new county government and its citizenry was clouded by the War in 1812 between the United States and Great Britain, with hostilities brought to the shores of Lake Erie. The village of Cleveland was the site of a military fort and hospital, a base for supplies, and an assembly point for troops; thus the small community was inevitably drawn into the drama of the conflict heightened by fears of invasion. But on September 10, 1813, a confrontation between British and American fleets, one where Clevelanders claimed to have heard the thunder of gunfire some 80 miles away, culminated with a victory for the United States on Lake Erie near Put-in-Bay, led by Oliver Hazard Perry. Having withstood the threat of invasion and encouraged by its contributions to the war effort, Cleveland and Cuyahoga County looked forward with confidence to the future. And the citizens' self-assurance was not misplaced, as the 1820s witnessed the genesis of the Ohio and Erie Canal, linking Lake Erie at Cleveland with the Ohio River at Portsmouth. This major internal improvement would foster the economic development of the growing community along Lake Erie and on the banks of the Cuyahoga.

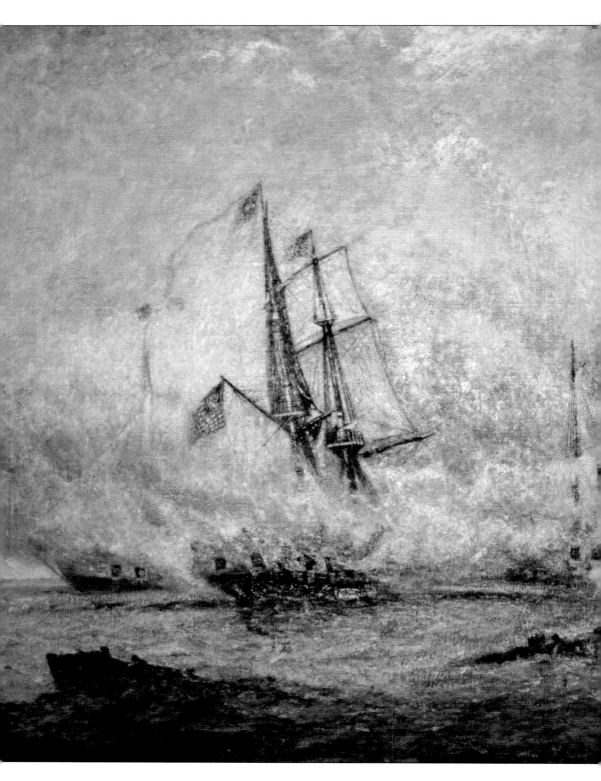

This 1913 oil painting by Cleveland artist Orlando Schubert commemorated the 100th anniversary of the Battle of Lake Erie. The naval encounter depicted was not only pivotal to the outcome of the War of 1812 but also held great significance for recently established Cuyahoga County. With the American victory and the signing of the Treaty of Ghent, the development of Cuyahoga County could proceed unabated. (Courtesy of the Cuyahoga County Archives and the Information Services Center.)

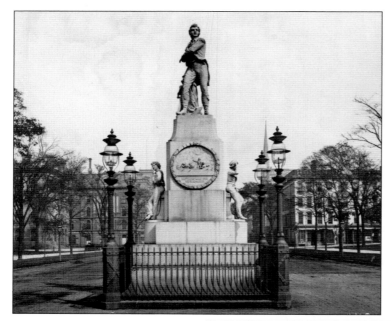

The Oliver Hazard Perry statute was dedicated in 1860 on Cleveland's Public Square to commemorate the commodore's victory at the Battle of Lake Erie. The monument was created by William Walcutt, a Columbus sculptor, and his representations of a midshipman and a cabin boy were added to the statue a few years later and placed below and to the side of the commodore's figure.

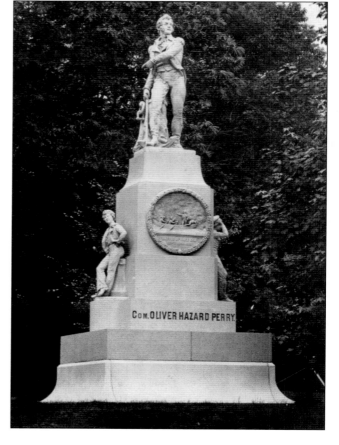

The Perry monument was moved to the southeastern quadrant of the Public Square until replaced by the Soldiers and Sailors Monument in 1892. After being mothballed for a few years, this view shows the new home of the commodore's statue in Wade Park, close to the University Circle area. But construction on the Cleveland Museum of Art in 1913 would displace the monument once more, and it would subsequently be placed in Gordon Park.

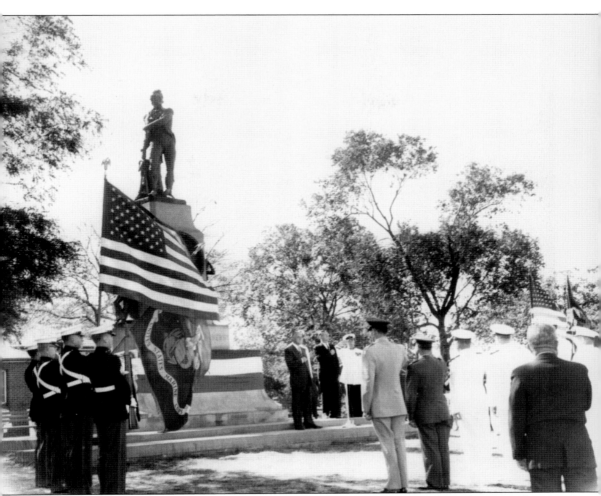

In 1929, the Early Settlers Association had the Perry monument replaced with two bronze replicas. One was placed in Gordon Park, and the other was sold to Rhode Island. The Settlers gave the original Walcutt Monument to Perrysburg, Ohio. A commemoration of the 150th anniversary of the Battle of Lake Erie was held on September 10, 1963, in Gordon Park and was sponsored by the Early Settlers Association. Notables seen in the photograph include D.L. Harbaugh, the president of the Early Settlers Association, and Cleveland mayor Ralph Locher (believed to be to the left of the saluting soldier facing the camera). Cleveland's replica would be moved once again to Huntington Park, adjacent to the current Cuyahoga County Courthouse, where it was rededicated on September 13, 1991. Although memorialized in the United States, Oliver Hazard Perry would die outside of the country while on an expedition to Venezuela. He contracted an illness born by insects native to the area and was initially buried in Port of Spain, Trinidad. Perry's remains would later be transferred to Newport, Rhode Island.

21

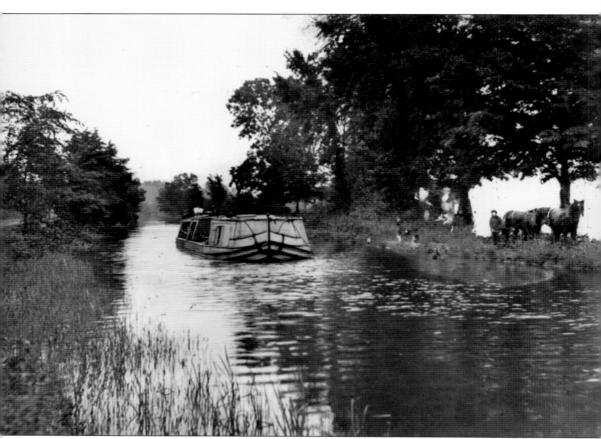

The Ohio and Erie Canal was built between 1825 and 1832 at a cost of $4.3 million, and its 308-mile course linked Cleveland on Lake Erie with Portsmouth on the Ohio River. The canal was dug with the hands of laborers who earned $5 per day, in addition to room, board, and a ration of whiskey. The section between Cleveland and Akron was opened on July 4, 1827. The advent of the railroad would eventually contribute to the end of the canal era, as this mode of transportation was not dependent on water and could transport people and goods more quickly than through canal travel. This 1894 view of a canal boat on the Ohio and Erie Canal was taken south of the five-mile lock. The lock was located near the Austin Powder Company in what was once Newburgh Township. The Austin brothers bought out the Cleveland Powder Company in 1867, and the transaction included the purchase of 400 acres at the five-mile lock site.

Three

AN AGE OF DEVELOPMENT AND REFORM
1830–1859

The population of the county numbered some 1,459 souls in 1810 and would expand to 6,328 inhabitants in 1820. But the number was nearly doubled by 1845, when 12,000 were living on both banks of the river and Cuyahoga County, the beneficiary of its burgeoning towns, was declared the largest county in the Western Reserve in 1840. Both Cleveland and Ohio City, located on the Cuyahoga River's western bank, were named cities in 1836. Ohio City, described by the *First Directory of Cleveland and Ohio City, 1837–1838* as "pleasantly situated on the west of side of the Cuyahoga River, on a site of commanding eminence," had some 370 houses and a population of approximately 2,400 in 1837–1838.

Cuyahoga County would gain recognition within the Western Reserve not only as a result of its size but also for its role in the anti-slavery movement as the national debate over slavery dominated the antebellum years. Many courageous residents participated in the operation of the Underground Railroad, a vast network of individuals who helped fugitive slaves escape to freedom in the North and in Canada. Homes and churches in the county would later be identified as stops on this pathway to liberty, and "Hope" was the code name given to Cleveland as the enslaved neared the Promised Land across Lake Erie.

While some Cuyahoga County residents sought to reform society through the eradication of slavery, others sought change by creating a utopian society dedicated to the principles of peace and equality, where all lived communally, in celibacy, and in self-sufficiency. In 1822, the North Union Shaker community, "the Valley of God's Pleasure," was established in Warrensville Township, including what is now Shaker Heights and parts of Cleveland Heights. The community reached its peak in 1850 with 300 members, but by 1889 the membership had declined to 27 persons and the North Union settlement was abandoned.

In 1946, Cleveland held its sesquicentennial celebration, and the city's sesquicentennial commission, created by Mayor Thomas Burke, planned various activities for the 150th anniversary of Moses Cleaveland's landing. Although this photograph is not dated, it undoubtedly reflects a program sponsored during the sesquicentennial. The program aired on WGAR radio and featured county engineer John W. McWilliams and a Moses Cleaveland reenactor.

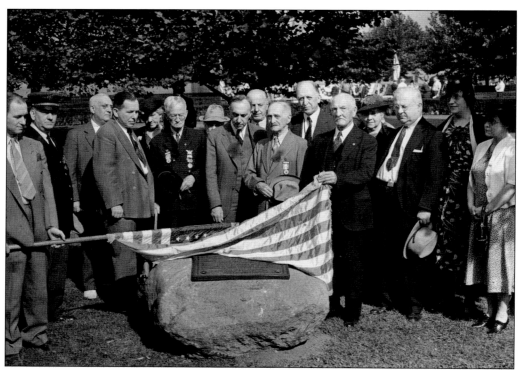

In this view, members of the Early Settlers Association are lifting the flag from a marker located near the site where Fort Huntington was established in 1813. It was dedicated on the 125th anniversary of the founding of Cleveland in 1921. The gentlemen identified are, from left to right, Lewis C. Carran Jr.; county commissioner John F. Curry; Edwin A. Johnson, age 97; Leo Weidenthal; Geo Cogswell, age 95; and Hubert W. Blackman, age 93.

The 1858 Griffith Morgan Hopkins Atlas of Cuyahoga County illustrates the growth and development the county experienced during its first 50 years. The atlas insets not only represent the townships but also reference newer communities that were established over time like Berea, Brighton, Collamer Village, Doans Corners, Olmsted Falls, and Westview. The insets also reflect local business directories and identify institutions like schools and the names of landowners. (Courtesy of the Cleveland Public Library Map Collection.)

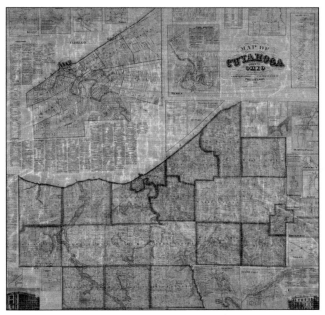

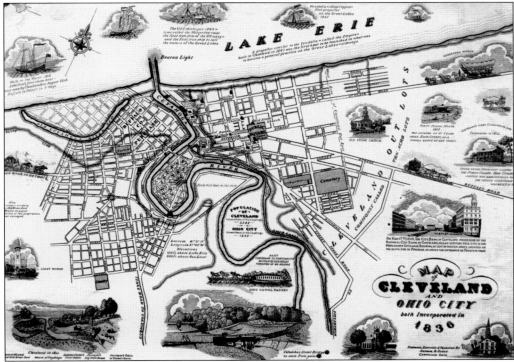

Cleveland and Ohio City existed as "sister" municipalities from their creation in 1836, but the two were quarrelsome siblings. The smaller Ohio City fought to prevent Cleveland from diverting commercial traffic away from its business district, and this competition came to a head in 1837, when Ohio City residents attempted to block the use of the Columbus Street Bridge. In 1854, the more dominant Cleveland annexed Ohio City.

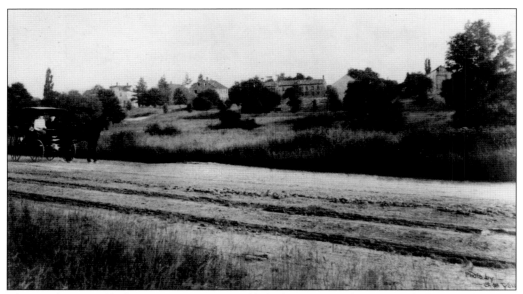

The North Union Shaker community was established in 1822 in what is now Shaker Heights. This religious sect's members were known for their communal and celibate lifestyle, industriousness, and self-sufficiency. This photograph, dated 1904, represents a view from North Park Boulevard, looking south toward Lee Road. The buildings visible include, from left to right, the Broom Shop, the "Middle family" house, two barns, and the meetinghouse seen in the distance.

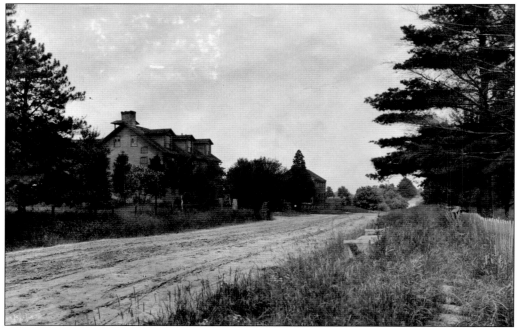

The zenith of the Shaker community occurred about 1850 as its population grew to 300 members. The enterprising Shaker community dammed the Doan Creek in two places, shaping the upper and lower Shaker Lakes and creating the waterpower needed to support a woolen mill, sawmill, and gristmill. This view, taken about 1905, identifies the settlement house of the Shakers on Lee Road.

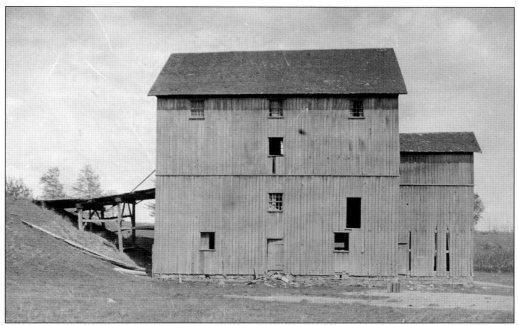

The Shaker community would wane after the Civil War, as fewer converts, half-hearted believers, and youth eschewing the rule of celibacy contributed to the loss of members. By 1889, there remained only 27 believers, and so the community disbanded. But during its prime, success at farming must have filled the Center family's north barn with the fruits of its harvest. The Center family would also be joined by the East, or Gathering, family and the Mill family.

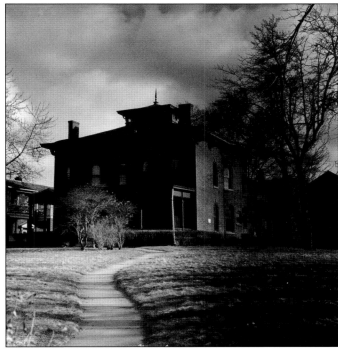

With an original section constructed in 1853, the Cozad Bates House is one of the oldest remaining buildings in the University Circle area of Cleveland, which was once part of East Cleveland Township. Built by abolitionist Andrew Cozad for his son Justus, the structure is also identified as place of refuge for escaped slaves on their road to freedom. The Cozad Bates House has been awarded National Register status and was designated a Cleveland Landmark in 2006. (Courtesy of Cleveland State University and the City of Cleveland Heights.)

The Asa Cady House, located in Cleveland Heights, Ohio, is thought to have been one of the safe havens on the Underground Railroad. Owner Asa Cady was vice president of the Cuyahoga Anti-Slavery Society. (Courtesy of Cleveland State University and the City of Cleveland Heights.)

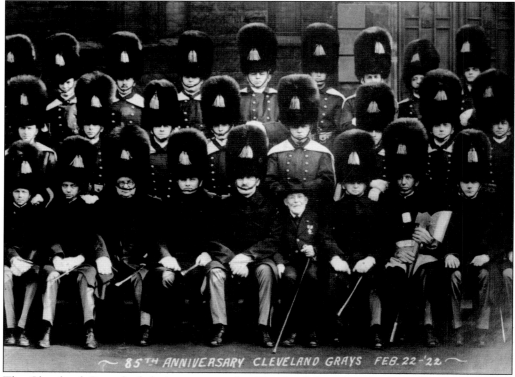

The Cleveland Grays had their genesis as the Cleveland City Guards, formed in 1837 to serve as a constabulary and as a force to protect against a Canadian invasion. The group eventually took its name from the color of its uniforms. The Grays would serve during the Civil War, the Spanish American War, and World War I. In this view, the unit poses proudly for its 85th anniversary in 1922.

Four

A TIME FOR WAR
AND A NEW BEGINNING
1860–1899

The Civil War marked a turning point for Cuyahoga County, as the city of Cleveland transitioned from a commercial community to a municipality that thrived on manufacturing. But while the Civil War brought new prosperity to Cleveland, it was perhaps outweighed by the toll in human lives. Approximately 10,000 men served in the Civil War, with 1,700 deaths and 2,000 injured or permanently disabled. To honor those noble dead, the Soldiers and Sailors Monument, completed in 1894 and situated on the southeast corner of Public Square, stands as a living memorial to those who fought for the preservation of the Union. And while Cuyahoga County citizens were never in danger from Confederate forces, the US Army established a prisoner of war depot on Johnson's Island overlooking Sandusky Bay, about 80 miles from Cleveland. It largely housed Confederate officers, and over 200 men are buried in the cemetery on the island. There were some notables with ties to Cuyahoga County that served the Union cause: Pres. James A. Garfield fought on the battlefield, and John Hay was a private secretary and military aide to President Lincoln. And despite the lingering wounds that would forever impact the people of Cuyahoga County, the decades after the war also witnessed the development of educational institutions and medical facilities, the establishment of new cemeteries for burial of the dead, the construction of courthouses to carry out the increasing responsibilities of county government, and the advent of venues for general entertainment like the Cleveland Driving Park in Glenville, which is reputed to be the first amateur driving club in America. Also, the arrival of significant numbers of immigrants, especially from Eastern and Southeastern Europe, to Cuyahoga County would leave an indelible imprint on the area's ethnic, social, and political makeup.

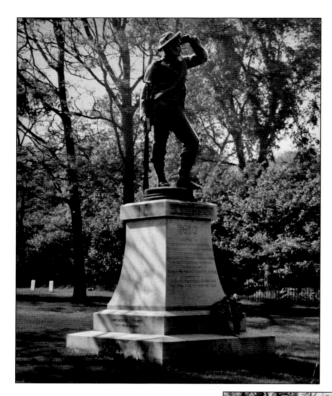

There are no Civil War battlegrounds in Ohio, but Cuyahoga County residents still remained near a community of Confederate soldiers. Officers, enlisted men, and civilians disloyal to the Union were incarcerated in a military prison on Johnson's Island in Sandusky Bay. *The Lookout*, sculpted in bronze by Moses J. Ezekial, was erected by the Daughters of the Confederacy in 1910 and stands watch over the graves of some 200 men.

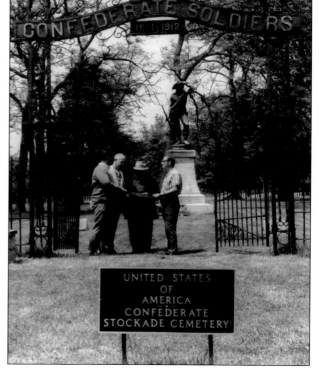

Johnson's Island has attracted the interest of local historians, and in this 1970 view Civil War buffs Dr. Richard Monroe, Dr. Richard D. Mudd, Edward Wells, and Donald Green stand at the gates of the Confederate cemetery; *The Lookout* statue is visible behind them. Monroe, Wells, and Green were members of the Bay Village Historical Society.

Abraham Lincoln visited Cleveland on two occasions, once on the way to his inaugural and a second time on the return to Springfield, Illinois, for his funeral. A public wake for the late president was held April 28, 1865, on the Public Square. Lincoln's body was placed on a catafalque, and two lines of over 90,000 mourners paid their respects all day and into the night. The coffin was shut at 10:00 p.m.

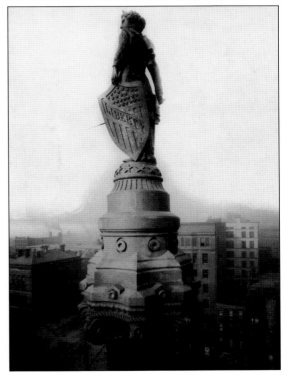

The Soldiers and Sailors Monument on the southeastern quadrant of the Public Square commemorates the Civil War. Designed by Levi Scofield and dedicated on July 4, 1894, the monument consists of a shaft surrounded at the base by a memorial room and esplanade. Groups of bronze sculpture represent battle scenes and the four major armed services. Perched on the top of the shaft is the Goddess of Freedom, and she symbolizes the qualities of the nation for which men fought and died.

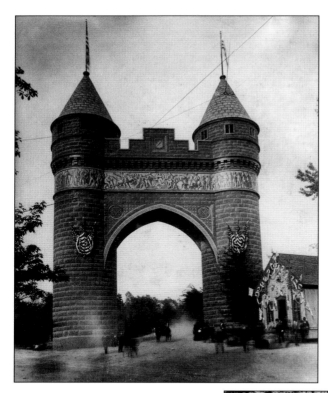

James A. Garfield was a native son of Orange Township and served in the Civil War as a major general, seeing action at Shiloh. Elected the 20th president of the United States in 1880, his tenure in office was abbreviated when he became the victim of an assassin's bullet in 1881. A memorial, designed by George Keller, was later erected in his memory and dedicated on May 30, 1890, in Lakeview Cemetery.

John Hay was born in Indiana and saw brief action during the Civil War. Hay served, however, as private secretary to Abraham Lincoln and later represented his country as secretary of state under William McKinley and Theodore Roosevelt. He is buried in Lakeview Cemetery with his wife, Clara Stone, sister of Flora Stone Mather. Hay's monument bears the following inscription: "The Fruit of Righteousness is sown in peace of them that makes peace."

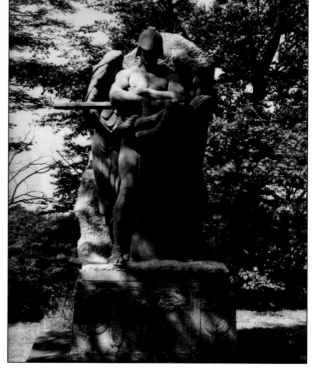

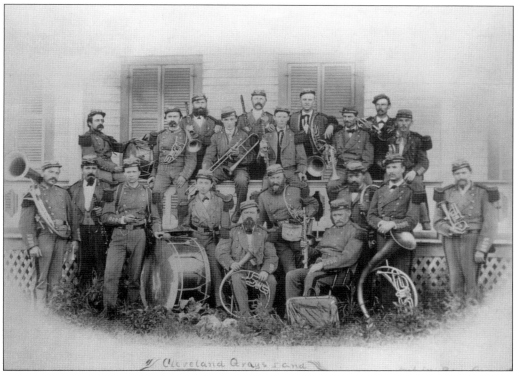

The Cleveland Grays served during the Civil War, initially designated as Company E, 1st Ohio Volunteer Infantry (OVI). The Grays were on duty with the 150th OVI when Confederate general Jubal Early attacked Washington in 1864 and saw action at Vienna Station and the First Battle of Bull Run. In a lighter moment, the Cleveland Grays Band gathered at Put-in-Bay Island during the 1870s. Today the Grays exist to preserve the area's military heritage and promote patriotism.

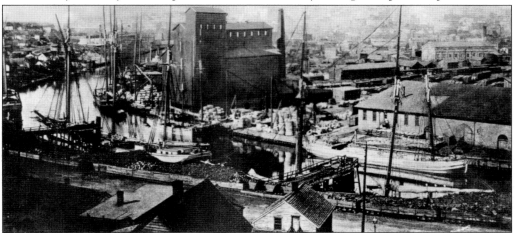

The Cuyahoga River, the lifeblood of the county, flows south and north over a 100-mile course and derives its name from a combination of Native American references commonly translated as "crooked river." This view shows a bustling riverfront at Cleveland in 1865 dominated by various watercraft; the prominent building in the center represents what was later known as the Gardner, Clark, and York Grain Elevator Company.

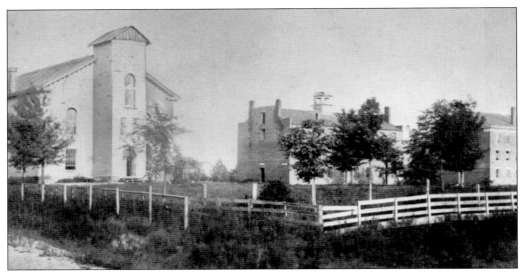

Baldwin Institute opened in 1846 as a preparatory school in Berea, commissioned through the Methodist Episcopal Church. It became Baldwin University in 1855, and this view shows original university buildings, which are, from left to right, Hulet Hall, North Hall, and South Hall. Hulet Hall was built with student labor and at times by lantern light. The Civil War interrupted the students' work, but the hall was completed in 1867.

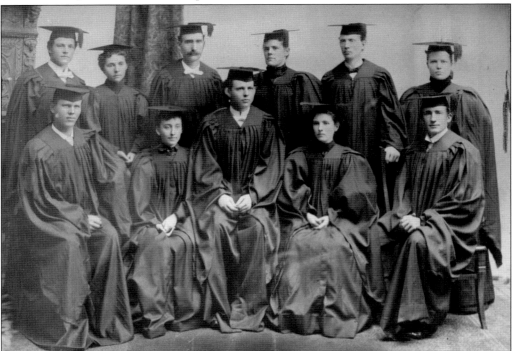

German Wallace College was a separate school established on land given by James Wallace in 1863. The school agreed with Baldwin University not to duplicate courses and to share academic studies. The two schools merged in 1913 to form Baldwin Wallace College. The 1896 graduates pictured here comprised the 15th anniversary class of Baldwin University.

John Carroll University had its origins on Cleveland's west side as St. Ignatius College, a Jesuit-operated liberal arts institution for men. The college is seen here about 1889 in a temporary building at the corner of Carroll and West Thirtieth Streets. The school would later purchase land to move the institution east to a location in University Heights.

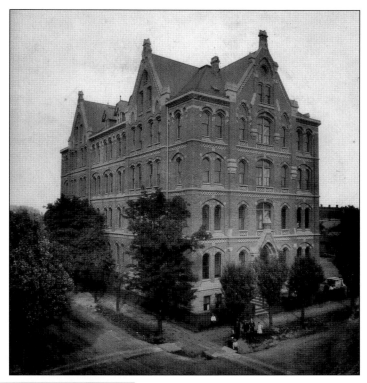

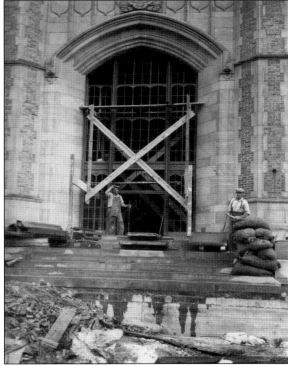

St. Ignatius College, temporarily named University College, became John Carroll University in 1923, and work on the school's new site in University Heights began in 1931. The buildings were not completed until 1935, and in that year workers could be seen finishing work on the entrance to the campus Administration Building. In 1968, the all-male undergraduate college officially became coeducational. Women had been admitted to the university's graduate school since 1934.

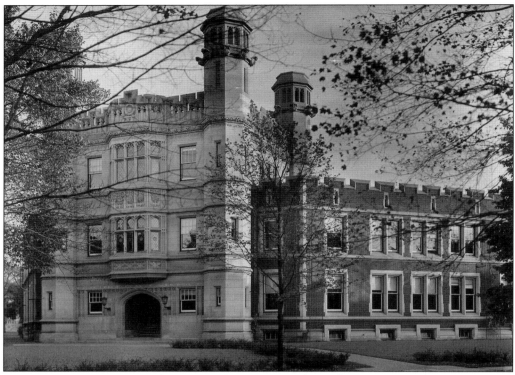

The College for Women was established as part of Western Reserve University in 1888. Philanthropist Flora Stone Mather contributed her money, time, and talent to the support of this college, and so it was named after Mather in 1931. The Flora Stone Mather Memorial Building, housing classrooms and offices, was designed by prominent architect Charles F. Schweinfurth and completed between 1911 and 1913. Mather died in 1909, and her will contained bequests to over 30 educational, religious, and charitable institutions. (Courtesy of the Case Western Reserve University Archives.)

Cleveland General Hospital was established in 1894 and opened later that year in a building on Woodland Avenue, near East Twentieth Street, with a capacity of 75 beds. The main purpose of the hospital was to offer clinical training for medical students and as a training school for nurses. The hospital was renamed St. Luke's in 1906. Several nurses posed for this photograph on the lawn in front of the hospital.

St. Alexis Hospital was established in 1884 by the Order of St. Francis of the Perpetual Adoration with the mission of ministering to the health needs of a working-class and immigrant population and treating the victims of industrial accidents. The hospital was first located on the north side of Broadway Avenue at McBride Street in an eight-room house, but a main building was completed in 1885. This view of St. Alexis was dated 1910.

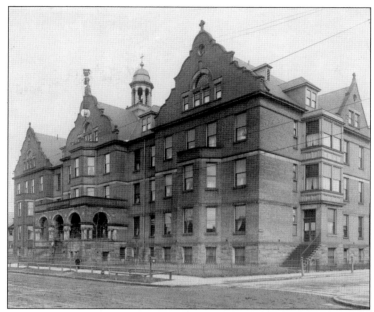

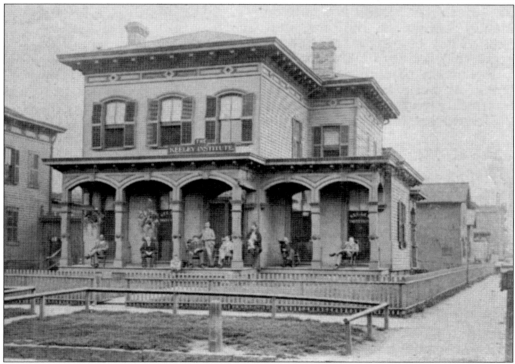

Dr. Dwight E. Keeley had studied alcoholism, beginning with his service as a physician during the Civil War. He held that drunkenness was a disease that could be cured. Keeley designed a treatment for alcohol, drug, and opium diseases and opened the first Keeley Institute in Dwight, Illinois, around 1879 or 1880. The institutes opened throughout the United States, including one in Cleveland on Woodland Avenue during the 1890s.

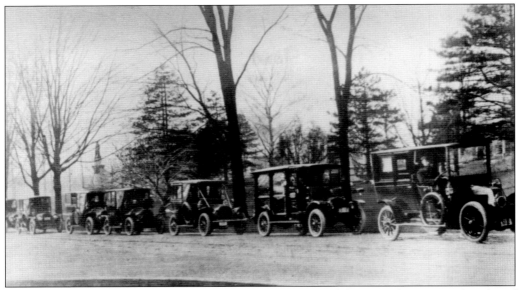

The first lots were selected at Lake View Cemetery in 1870, and despite its location at the edge of the city of Cleveland, the cemetery's natural landscape proved a destination for a family drive on a Sunday afternoon. A 1903 funeral at Lake View marked the first occasion where automobiles, rather than carriages, were used and included the first hearse made by the White Motor Co.

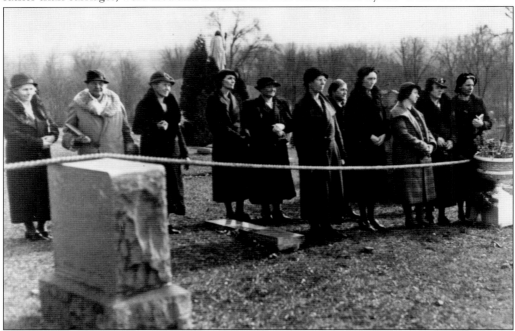

Calvary Cemetery, located at the Cleveland and Garfield Heights border, had its first burials in November 1893 and was opened to accommodate the developing need for a new and more expansive area for the burial of Catholics in the county. In 1937, news that the grave of a young woman in Calvary Cemetery was the site of healing miracles drew large crowds. The grave was eventually cordoned off to prevent relic seekers from destroying it.

The third Cuyahoga County Courthouse of 1858 was built in the northwest area of Public Square and completed in 1860 at a cost of about $152,000. J.J. Husband, the designer but not the builder of the courthouse, had his name stricken from the cornerstone of the structure in April 1865 when he was heard to suggest President Lincoln's death was well deserved. In later years, criminal cases were heard in the third courthouse.

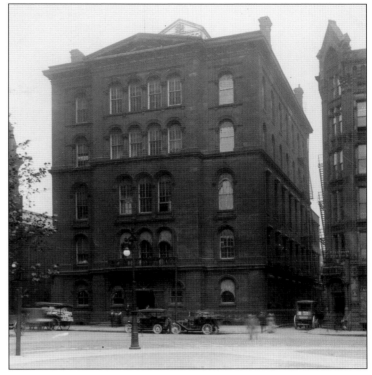

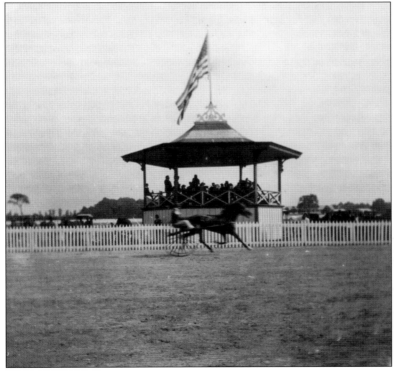

Glenville Race Track was built in 1870 by the Cleveland Driving Park Co. The track was a successful attraction and featured harness and later auto racing. When Glenville mayor Frederick Goff found betting illegal in 1908, the track was deserted, and the center for racing moved to the village of North Randall. In this view, horse and driver appear to be passing a reviewing stand.

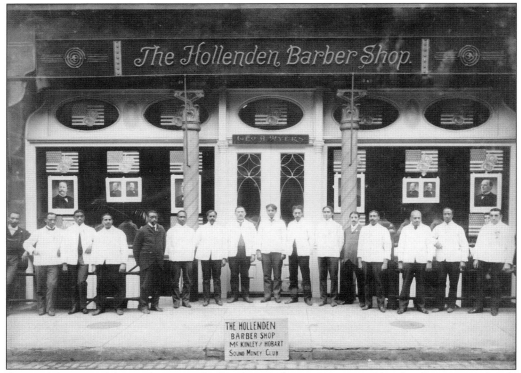

George Myers, an African American barber from Baltimore, came to Cleveland in 1879 and with the financing of prominent citizens purchased the Hollenden Barbershop in 1888. The Hollenden House, the city's finest hotel, attracted many local political figures, and Meyers's modern barbershop became a center for political discussion. Myers, seen next to the right end and below the image of President McKinley, was twice a delegate to the Republican National Convention.

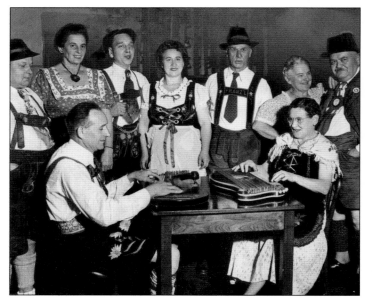

Immigrants from Germany began arriving in Cleveland in significant numbers beginning in the 1830s, and they settled both on the east and west sides of the Cuyahoga River. Statistics show that Germans were the largest group coming to Cleveland until the mid-1890s. They fostered forms of musical expression through bands and singing societies, and this is illustrated by Mr. and Mrs. Oscar Jelinek playing zithers as an accompaniment for singing.

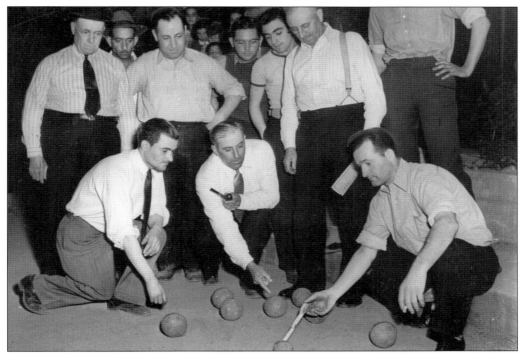

Italian immigration to Cleveland, particularly from southern Italy, began in earnest after the Civil War. They settled in distinct neighborhoods one of which, Little Italy, maintains its ethnic and cultural identity to this day. In this view, boccie season came early in 1941 during premature summer weather, as a group of men have convened on a court at Mayfield and East 120th Streets. The boccie courts were sponsored by the Dopolavoro Club, the latter organizing year-round community events.

In search of employment, the Croatians from states surrounding Ohio moved to Cleveland beginning about 1860. Many found jobs in shops and factories, while others worked for the railroad. Like other nationalities from southeastern Europe, music was an important influence, and as three-year-old Joe Zunich looks at the camera, tamburitza manufacturer John Bencic—one of only two in the world—plies his craft.

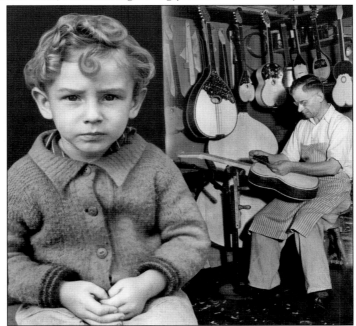

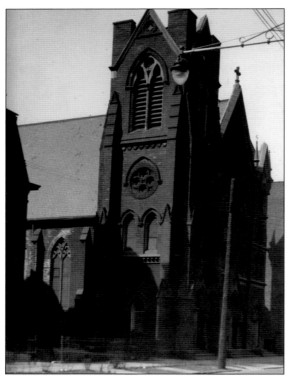

The church was primary to the life of many ethnic neighborhoods, including the Irish community, and St. Bridget's on East Twenty-second Street served a moderately wealthy Irish population. But as residents began to move farther east, the area gradually lost its character as an Irish enclave. And, in 1938, St. Bridget's Church merged with St. Anthony's Church, an Italian parish. This view shows St. Bridget's in 1935, when it celebrated its 75th anniversary.

St. Agnes Church on Euclid Avenue and East Eighty-first Street was dedicated in 1916 and served an upper-middle-class community that included many Irish. Although the church was demolished in 1970, a 130-foot bell tower, visible in this image, still stands as a beacon and reminder of an earlier community of faith.

After 1860, some immigrant Poles settled in Berea to work in the stone quarries, while others would find work in industries close to railroad lines on the lakefront and to the north. There were some members of the Polish community who settled in the neighborhood near East Seventy-ninth Street and Superior Avenue known as Poznan. St. Casimir's, formed in 1892, was described in 1940 as the "social and educational, as well as religious center," for that neighborhood.

Some members of the Jewish community found that the Montefiore Home for the Aged and Infirm Israelites did not meet the needs of Orthodox Jews, and in 1906 the Hebrew Orthodox Old Age Home was established on East Fortieth Street. Those pictured are, from left to right, Solomon Weiner, Jacob Wald, and Joseph Purer, who are all gathered to read from the sacred texts in the Hebrew Orthodox Old Age Home, then located on Lakeview in Glenville.

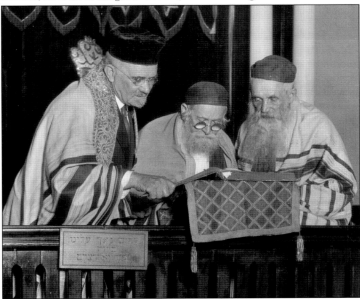

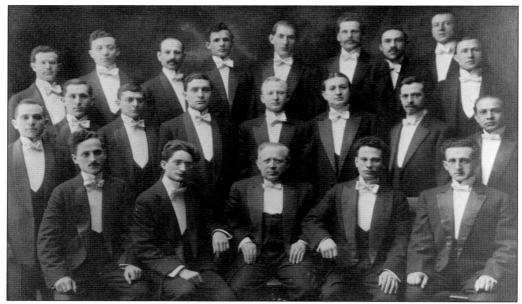

Music has always been part of the Jewish experience, both secularly and liturgically. Frank Novodworsky, a musical conductor, is seen here front and center with the members of the Jewish Singing Society in 1909. The all-male chorus did not include female members at the time the photograph was taken.

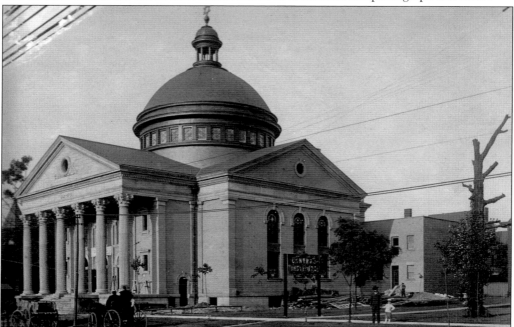

Jewish men and women have been in Cuyahoga County since 1837, with the earliest population from Germany to be later followed by Jewish Russians, Poles, and Romanians. B'nai Jeshurun was the third-oldest congregation and was established in 1866 by Jewish Hungarians. The congregants met in several locations, and in 1906 B'nai Jeshurun built a synagogue at East Fifty-fifth Street and Scovill Avenue.

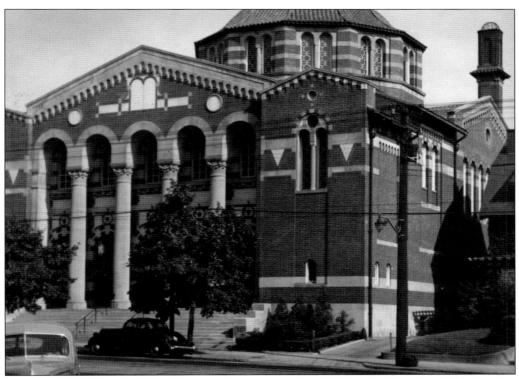

In 1926, B'nai Jeshurun dedicated a new synagogue on Mayfield Road in Cleveland Heights. The building, designed by Charles Greco of Boston at a cost of $1 million, was more familiarly known as the "Temple on the Heights." It became the first Jewish congregation to move to the suburbs. In 1980, B'nai Jeshurun moved to a new synagogue in Beachwood, selling its building complex that would later be know as the Civic.

Temple-Tiffereth Israel, known to many as "the Temple," stands as the second-oldest existing Jewish congregation. Accepting the Reform tradition in 1873, Rabbi Moses Gries led Tiffereth Israel to the vanguard of Reform Judaism. Under the leadership of Rabbi Abba Hillel Silver, Gries's successor, land was purchased at Ansel Road and East 105th Street for a new $1.5 million synagogue that was dedicated in 1924. Here, in 1935, the Temple celebrated its 85th anniversary.

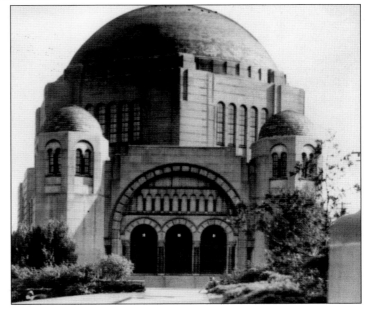

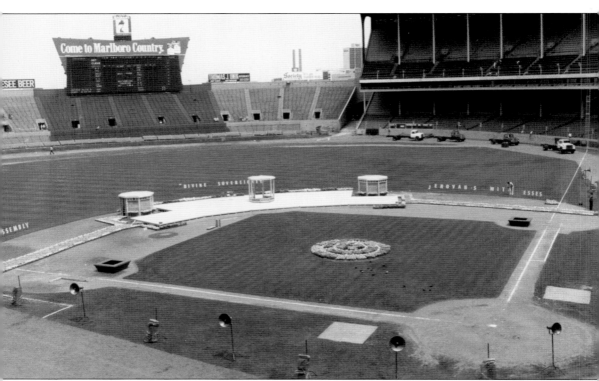

The Jehovah's Witnesses, another religious tradition established as the Watchtower Bible and Tract Society in 1881 by Charles Taze Russell, arrived in Cleveland in the late 1890s, primarily as visiting speakers who came to preach the message of the Kingdom. The Witnesses have steadfastly believed that the world order is in its final days, which will be destroyed at Armageddon with Christ's Kingdom being established over all the earth. The group became Jehovah's Witnesses in 1931, using its name for God as derived from Scripture. In the 1920s and 1930s, students and congregations in Greater Cleveland met regularly in buildings later converted into Kingdom Halls. The first congregation was organized in Lakewood in 1938, and the inaugural Kingdom Hall was erected in 1946 on State Road. In 1975, the Witnesses gathered as a convention at Cleveland Municipal Stadium. The scoreboard with its ad for Marlboro stands in contrast to the religious intent of the convocation.

Five

WAR AND PEACE
1900–1919

The 1910 census named Cleveland as the sixth city in the United States with a population of over 560,000 people, and it was judged as one of the best-governed and most progressive cities in the country. By 1918, the county announced the opening of the Detroit Superior Bridge, joining its east and west sides, and this edifice stood as the largest steel- and concrete-reinforced bridge in the world. Cuyahoga County residents also took pride in one of its greatest natural resources, Lake Erie, and enjoyed boating and swimming along its southern shore. Entertainment for the whole family was also readily at hand in Luna Park, a recreational area located on Cleveland's east side. Luna Park occupied a 35-acre site that could boast rides, a dance hall, concert shell, and stadium, regaling young and old throughout Cuyahoga County from 1905 to 1929. Euclid Beach on Lake Erie was a family-friendly amusement park, where the sale or use of alcohol was prohibited at the direction of its owners. With thrilling rides, a dance hall, a beach for swimming, and the best frozen custard in the world, Euclid Beach drew in visitors from both sides of the river until its close in 1969.

But the promise of the new century would be marred by tragedy in 1908, when Lakeview Elementary School, located in Collinwood Village, would be destroyed by fire with children and teachers perishing in the blaze. And six years later, the murder of an Austrian archduke in far-off Bosnia would eventually impact Cuyahoga County, when the United States entered World War I in 1917. Citizens participated in war bond drives and other patriotic activities and sadly watched their sons board trains traveling toward military service. The two decades to follow would be even more turbulent.

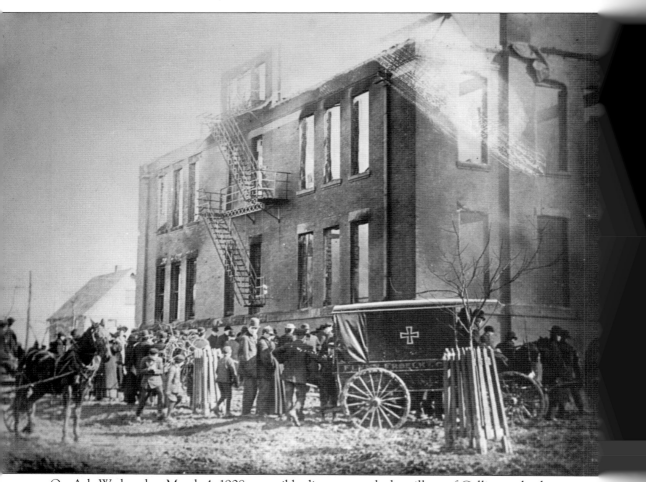

On Ash Wednesday, March 4, 1908, a terrible disaster struck the village of Collinwood, when Lakeview Elementary caught fire. In the aftermath, the building was destroyed and 172 children and three adults were killed. Although no exact cause of the fire could be determined, it was likely the result of the main steam line coming into contact with wood joists. An initial orderly evacuation was interrupted by the presence of heat and smoke that blocked the front doors, so many students ran to the rear exit. While the janitor worked to open one of the double outer front doors, the children were packed beyond capacity in the rear stairwell as some of the older youngsters piled on top of the smaller students in their haste to reach safety. This horrific incident did lead to more frequent school inspections and more stringent legislation nationwide. A new school, named Memorial, was built on an adjoining lot in 1910, and a botanical garden was created on the lot where Lakeview had stood in memory of the children.

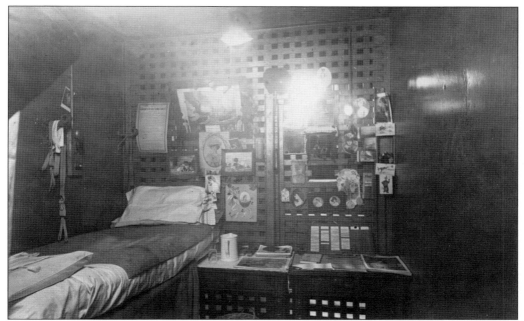

Life in the early-20th-century Cuyahoga County Jail may not have been as dreadful as one might suspect. The photograph shows a neatly made bed with tables near it that appear to serve as nightstands. Attached to the wall behind the bed and stands are family photographs and various images of lovely ladies, perhaps the 1910 version of pin-up pictures.

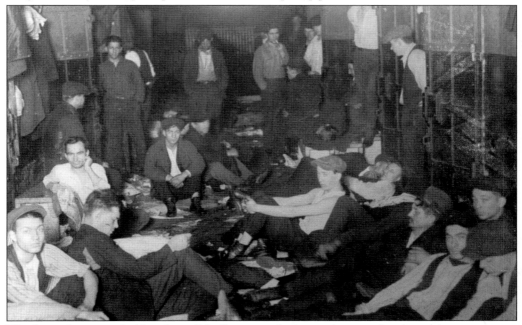

The faces of prisoners held in the jail's bullpen seem listless as they stand, or lie on thin mattresses, in dirty and overcrowded conditions. Voices in the community, including area club women, undoubtedly used such images to encourage the building of a new jail. The advent of the Criminal Court Building completed around 1930–1931 offered new jail facilities for such inmates.

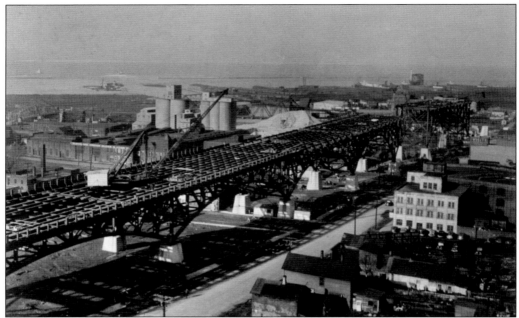

The Detroit Superior Bridge, now known as the Veterans Memorial Bridge, was constructed as a way of alleviating the growing problem of traffic congestion. The bridge was built over five years at a cost of over $5 million. This view, looking northeast, shows a section of the bridge's main superstructure.

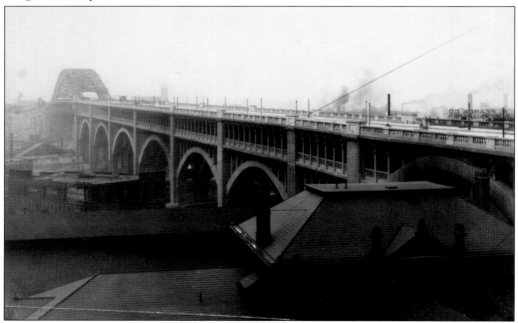

Thanksgiving Day 1917 marked the opening of the Detroit Superior Bridge. The bridge's upper deck was designed to carry vehicles and pedestrians, while the lower deck, known as "the Subway," carried streetcars. By 1930, the bridge was considered one of the busiest in the nation. This view faces west, as traffic is headed toward Detroit Avenue and its intersection with West Twenty-fifth Street.

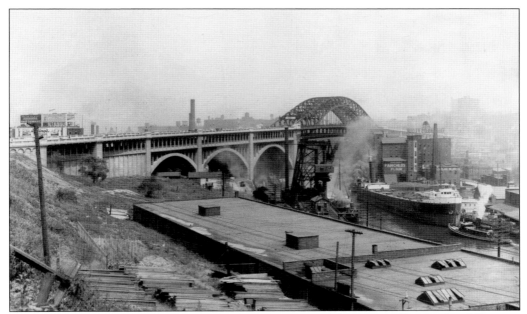

This image catches a glimpse of the bridge facing east toward downtown Cleveland and Superior Avenue. The Detroit Superior Bridge was the city's first high-level bridge over the Cuyahoga River, with a span, including the approaches, that totaled 5,630 feet in length. In the late 1960s, the bridge would be renovated to include two additional lanes of traffic. On Veterans Day 1989, the bridge was renamed Veterans Memorial.

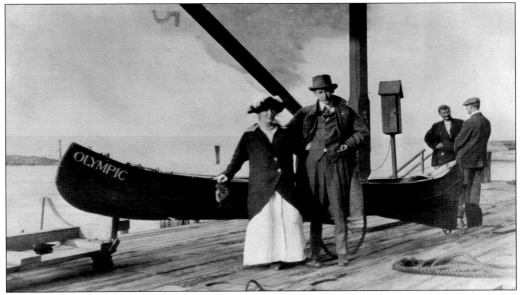

Cuyahoga County's romance with Lake Erie has long been evident. The Cleveland Yachting Club was established in 1878 and incorporated as the Cleveland Yacht Club in 1888. The club procured a lease of the lakefront at the foot of Erie (East Ninth) Street for a new clubhouse dedicated in 1895. In this view, a fashionable young couple poses before a boat named the *Olympic* at the yacht club on East Ninth Street.

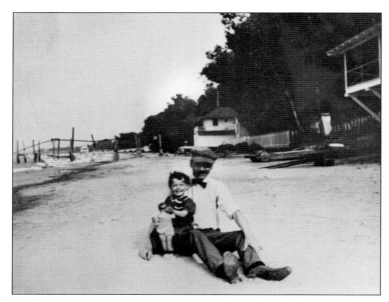

Bay Village, once part of Dover Township, lies at the western boundary of Cuyahoga County. Affluent citizens purchased summer homes here after the Civil War to enjoy recreational opportunities along the lakeshore. In the mid-1920s, a dapper gentleman and, one would assume, his daughter and her doll are enjoying a day on the lakefront.

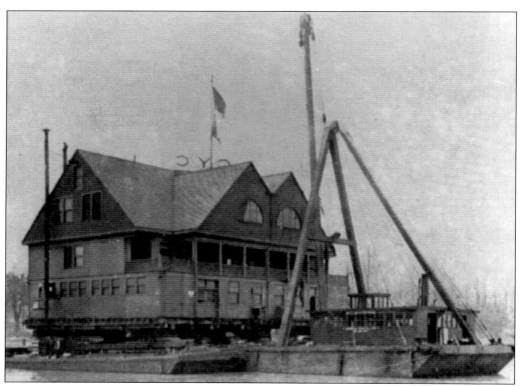

In 1914, the Cleveland Yachting Club (CYC) and the Lakewood Yacht Club agreed to a merger. As part of the agreement, the decision was made to move the building that housed the club from its location at the foot of East Ninth Street to the Lakewood Club's site on an island near the mouth of the Rocky River. The clubhouse was placed on three barges to make the trip.

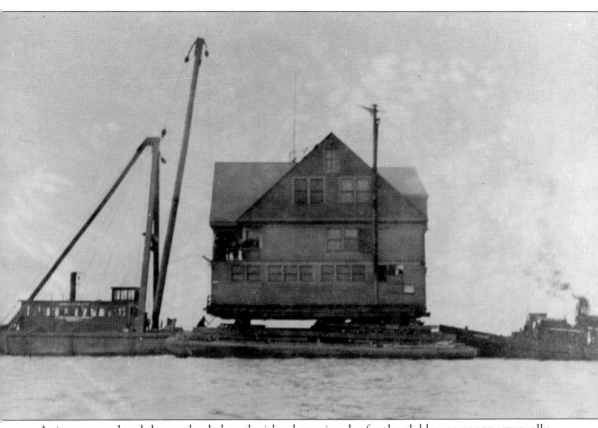

As it was towed and then unloaded on the island, moving day for the clubhouse was an unusually mild day in mid-November. The old Lakewood Yacht Club building was joined to it for use as a dining area. Despite its healthy membership and good reputation, the CYC went into bankruptcy. Later a new club was created and survived the Depression without any employees. Loyal supporters held things together, and shortly after the repeal of Prohibition members held a stag lobster dinner for "two bits and a dime." A total of 643 people attended, and the CYC turned a profit and generated positive publicity. In 1949, the club was able to purchase Rocky River Island, originally Indian Island. By its 75th anniversary in 1953, the club paid off its mortgage and was able to consider new improvements. Today the CYC offers year-round activities, is home to over 300 powerboats and sailboats, and has some 700 members.

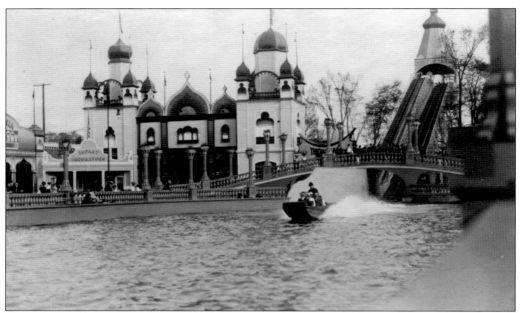

Luna Park opened in 1905 and was situated on 35 acres, surrounded by Woodhill Road, East 110th Street, and Woodland and Ingersoll Avenues. A mecca of entertainment for Cuyahoga County residents, many enjoyed the Shoot the Chutes. This was a ride operated by the use of pulleys dragging the boat up a right incline and shooting it down a left decline onto the water. In this 1910 photograph, the boat is just hitting the water.

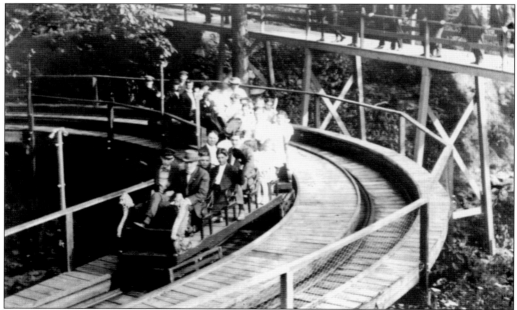

Luna Park closed at the beginning of the Depression and was razed by 1931. The last remnant of the once successful amusement park, the roller rink, burned in December 1938. A happy throng is shown here in 1910 enjoying the thrills of a roller coaster. Other amusements included a carousel, Ferris wheel, funhouse, and a dance hall

Euclid Beach was another amusement park inaugurated at the dawn of the 20th century that drew large crowds and gained a national reputation as one of the best. Euclid Beach opened in 1894, but it was not until 1901 that Dudley Humphrey purchased the park and made possible many new innovations, including expanded beach and bathing amenities. This 1936 photograph offers an aerial view of the park.

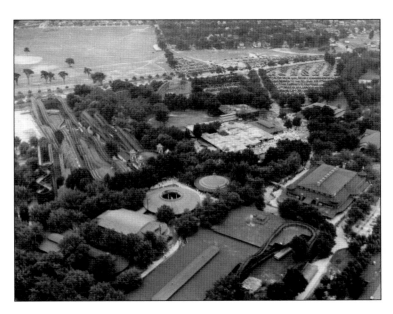

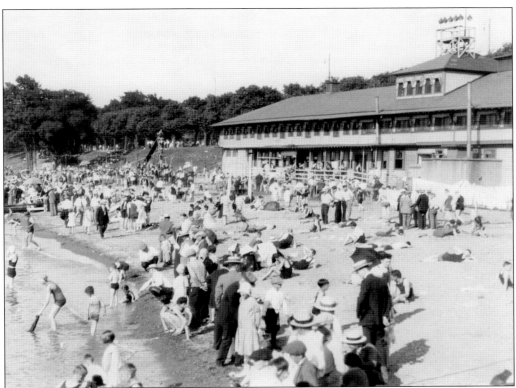

Euclid Beach offered its customers more than just rides, and many came to enjoy the bathing beach on a warm summer day. The park under the Humphrey family's operation was a true family destination, where the sale or consumption of alcohol was forbidden. Euclid Beach's popularity continued into the 1960s, but various socioeconomic factors led to its decline. The park finally closed in 1969.

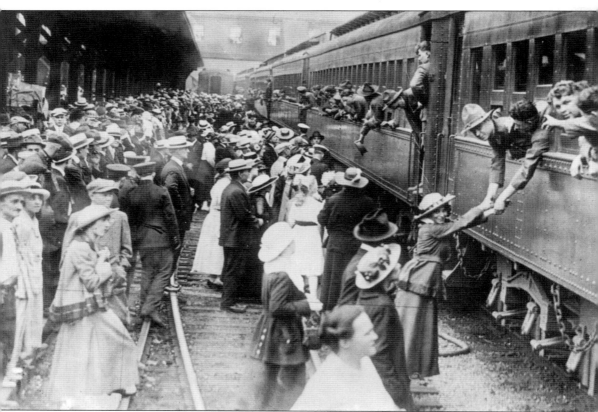

Idyllic days at the beach were interrupted by the entry of the United States into World War I on April 6, 1917. Cuyahoga County was already on the alert, as citizens had been stunned earlier by the sinking of the *Lusitania* in 1915 and the loss of seven area residents who were among 14 Americans killed on the torpedoed British liner. When Germany resumed unrestricted submarine warfare during March 1917, Clevelanders attended war meetings and contributed to the formation of 500 ships that constituted the "mosquito fleet" on Lake Erie. Shortly after the United States declaration of war, the county draft board was established to implement the new Selective Service System, and by the end of 1917 the area had sent 25,000 draftees to join 8,000 volunteers in the conflict. Here relatives and friends have gathered at Union Depot to bid farewell to the 5th Regiment of the Ohio National Guard in 1917.

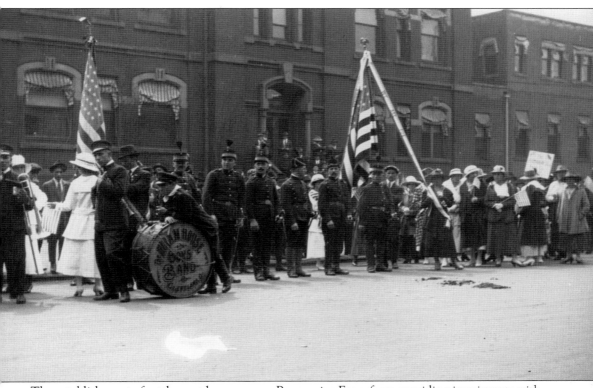

The establishment of settlement houses was a Progressive Era reform providing immigrants with institutions where they could seek assistance. Hiram House was the first settlement in Ohio and was formed by students from Hiram College, including, most notably, George Bellamy. Hiram House was located briefly on Cleveland's west side but would eventually take up permanent residence on the east side at 2723 Orange Avenue. At Hiram House, immigrants could take classes in English, as well as American customs and history, to prepare them for life in the United States and to help them pass examinations for citizenship. George Bellamy, one of the settlement's founders, served as Hiram House's director from 1897 to 1946. The house on Orange Avenue ended its operation in 1941, but Hiram House Camp in Chagrin Falls continues to offer outdoor educational and recreational activities for youth throughout the year. In this photograph, the Hiram House boys' band is poised to participate in a patriotic event during World War I.

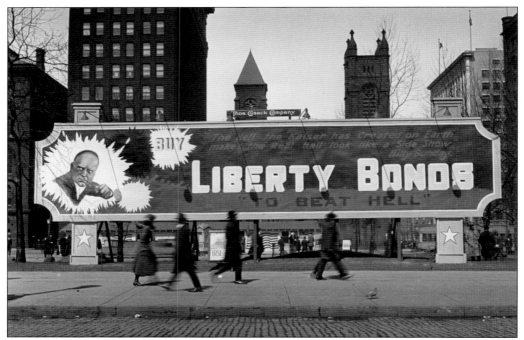

The US Treasury's Liberty Loan campaigns were very successful in the Cleveland area, as the citizenry oversubscribed the first two initiatives by $70 million. The face of Billy Sunday, former major-league ballplayer and evangelist, is seen on a banner in Public Square, which encouraged passersby to buy Liberty Bonds. The banner also makes reference to the "hell" on earth created by the actions of the Kaiser.

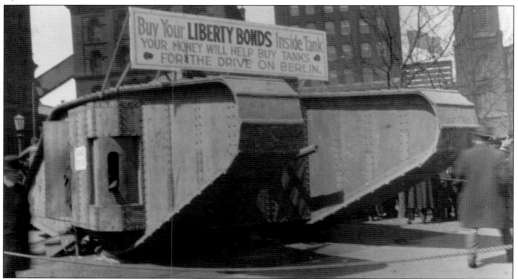

A tank was also placed on Public Square, where patriotic women and men could purchase their Liberty Bonds. According to the signage, the donations would help to buy tanks for the drive on Berlin. County residents also demonstrated their love of country by attending a huge Flag Day Pageant in 1918 that attracted 150,000 participants.

Six

BOOM AND BUST
1920–1929

The roar of the 1920s ended in the bust on Wall Street, and Cuyahoga County would move from the heights of prosperity into the depths of the Great Depression. During the banner years, Cleveland played host to the 1924 Republican National Convention with all the fanfare attendant on such an event. Republicans would return to Cleveland in 1936 to nominate Alf Landon as their presidential candidate.

The Twenties also saw the growth of the metroparks, the brainchild of William Stinchcomb, who would serve as Cuyahoga County engineer and the first director and secretary of the Cleveland Metropolitan Park District. Known as the Emerald Necklace, the metroparks would come to envelop Cuyahoga County with 19,000 acres in 12 reservations, including Brecksville, Bedford, Euclid Creek, Huntington, North and South Chagrin, and Rocky River. A reverence for nature and a desire to celebrate Cuyahoga County's varied ethnicities culminated in the creation of the Cleveland Cultural Gardens, developed from a 50-acre strip in Rockefeller Park, which was a 254-acre park established in 1896 from land donated to the City of Cleveland by industrialist John D. Rockefeller. Beginning with the Shakespeare Garden in 1916, additional gardens celebrating other ethnic groups grew throughout the 1920s and 1930s. As evidenced by the dedication of the Armenian Garden on September 19, 2010, the gardens continue to flourish.

Progress was also evidenced in the area of transportation with the inauguration of Cleveland Municipal Airport in 1925.

The Republican National Convention came to Cleveland in June 1924 to nominate its presidential candidate, which marked the first national political convention to come to Cuyahoga County. This convention was also the first to be broadcast on the radio. The image of the elephant could be seen displayed all over town.

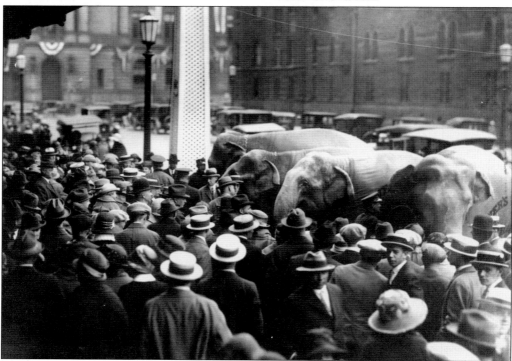

John F. Royal, manager of Keith's Palace Theater and quite the showman, furnished the real elephants that attracted a crowd in front of Public Hall eager to see the Republican Party's mascots. Cleveland's civic leaders offered the Republican Party free use of Public Hall and a $125,000 expense fund.

The Cleveland Grays, in full regalia, march in formation in recognition of the opening of the Republican National Convention on June 10, 1924. The buildings were decorated with patriotic bunting, and although it was late spring, the bystanders appear clad in coats suggesting a cool day in Cleveland.

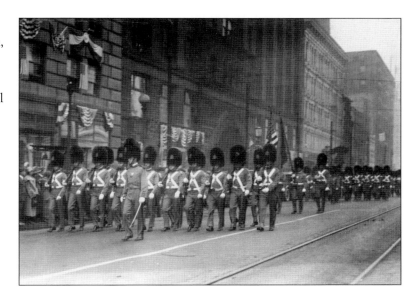

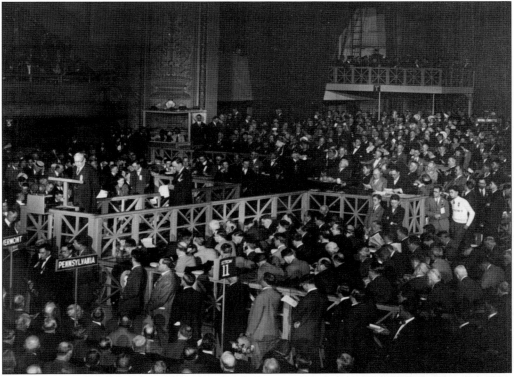

Ohio congressman Theodore Burton opened the convention in Public Hall on June 10, 1924, and is seen standing at the podium. Present at the convention were 1,100 delegates, including 118 women. The convention held little suspense regarding the name of the presidential nominee, as it was expected that Pres. Calvin Coolidge, who had assumed the office after the death of Pres. Warren G. Harding, would be the Republican choice.

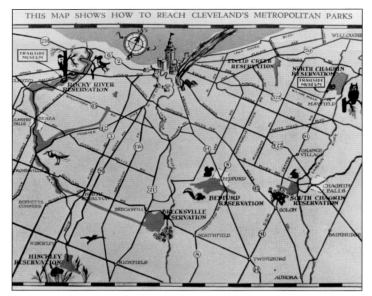

William Stinchcomb enabled the approval of state legislation allowing the creation of park districts and the establishment of the Cleveland Metropolitan Park District as a separate subdivision of the State of Ohio government in 1917. This map depicts the district in 1940 and identifies the separate reservations and the routes leading to each of the locations. In the years since its foundation, the park district has obtained over 18,000 acres of parkland.

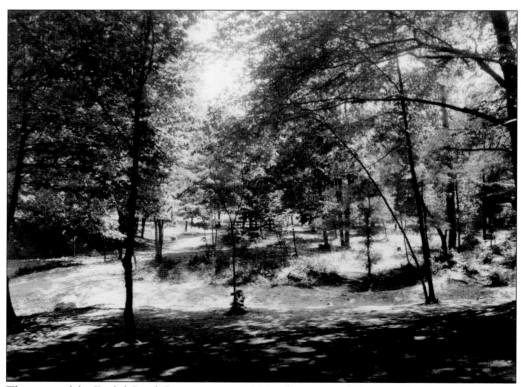

This view of the Euclid Creek Reservation in 1934 reflects a wooded area with an aura of serenity, which is far from the fast pace of everyday living. It has been the consistent policy of the Board of Park Commissioners to keep the parks in a state of nature and to regulate development to be in harmony with conservation efforts.

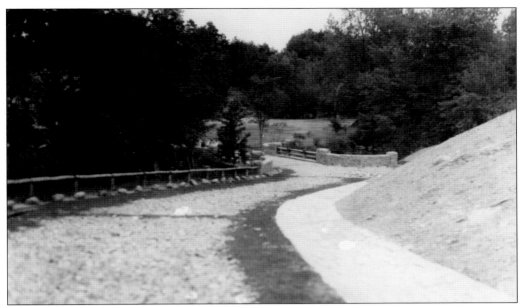

Another view of the Euclid Creek Reservation features a new bridge, constructed by the Civilian Conservation Corps, at the entryway to the picnic grounds. The CCC, established in 1933 under Pres. Franklin Roosevelt's New Deal, put 500,000 unemployed young men to work in the areas of reforestation and flood control. This measure was in keeping with the president's interest in conserving natural and human resources.

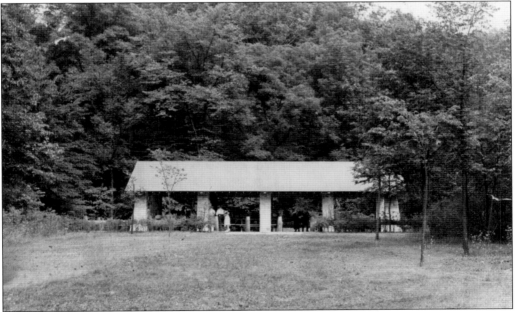

The shelter house at the Bedford Reservation is depicted in this 1937 photograph. Despite the park district's emphasis on maintaining green space in its original habitat, it did approve the development of trails, picnic areas, shelter houses, interpretive centers, and wildlife management areas, among others, to enhance the visitor's experience in the parks.

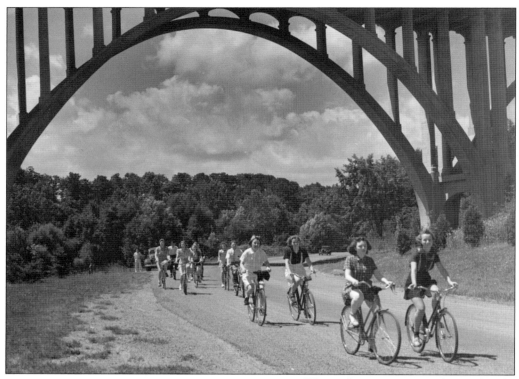

The parks were meant to be used and enjoyed by the county's populace, and it was perfectly captured in this 1939 photograph of bicyclers riding beneath a bridge in the Rocky River Reservation. At the time, it was suggested the growing popularity of bike riding had influenced the decision to create a new bicycle trail that was expected to open in the near future.

Not all recreation areas were under the aegis of the metroparks system, and this image of a winter wonderland, taken not far from the intersection of Superior and Lee Roads, was captured in Cleveland Heights' Cain Park on March 31, 1942. The park, named after Cleveland Heights mayor Frank C. Cain, also became home to the first outdoor theater that was municipally owned and operated. Every summer, thousands of visitors continue to enjoy musical and dance performances in the updated outdoor amphitheater.

"Gone fishing" could be the title for this view in Forest Hill Park. The lake is located at Forest Hill Boulevard and Lee Road, and the park consists of 184 acres of land in East Cleveland and 82 acres in Cleveland Heights. The area was originally part of the John D. Rockefeller estate, and in 1939 he gave the land to the two municipalities with the proviso that it be used for recreational purposes.

Moving west of the Cuyahoga River, Edgewater Park is found along the shores of Lake Erie at the western edge of the Memorial Shoreway. The City of Cleveland purchased the land in 1894, and the park was improved to include baseball diamonds, bathhouses, and many playground and picnic areas. Today Edgewater is part of the Cleveland Lakefront State Park and contains one of the largest bathing beaches in Cleveland.

The Cleveland Cultural Garden Federation, founded in 1925 as the Civic Progress League, has oversight for the landscaped gardens honoring the various ethnic groups that form part of the fabric of Cuyahoga County. The gardens, situated in Rockefeller Park, are located along East and Martin Luther King Jr. Boulevards, and the German Garden is pictured here in 1937. This view features the poets' corner that contains a bust of Gottwold E. Lessing.

In 1926, the same year the Civic Progress League became the Cultural Garden League, the Hebrew Garden was created; it is pictured here in 1936. Over the next few years, it would be joined, among others, by the American, Greek, and Syrian Gardens. During the ensuing years, gardens would be dedicated to the Romanian, Estonian, African American, Chinese, Finnish, and Indian communities.

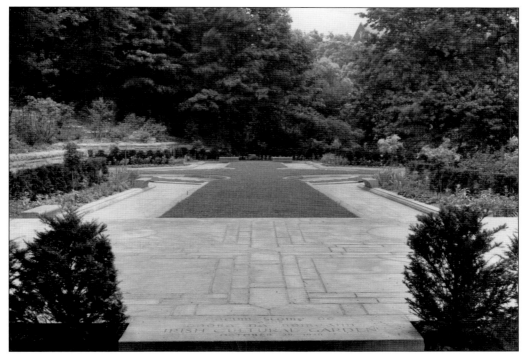

The large stone marker visible in the foreground records the dedication of this garden to the Irish. Immigrants from Ireland first arrived in Cleveland as early as 1820, and an Irish population of 500 was in place by 1826, many of who found employment on the Ohio and Erie Canal. By 1848, over 1,500 Irish immigrants were in the Cleveland area.

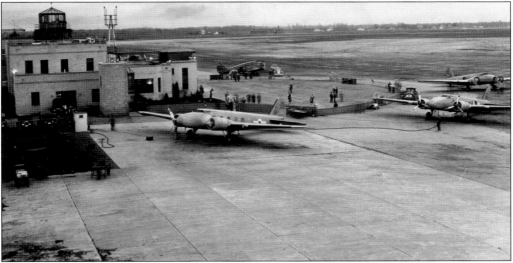

In 1921, the City of Cleveland sanctioned the plan for a municipal airport, prepared by city manager William R. Hopkins, and purchased 700 acres of land at Bookpark Road and Riverside Drive. Cleveland's favorable location on major airmail routes allowed it to become one of the nation's busiest airports during the late 1920s. This 1936 view shows five planes ready for takeoff and a building (left) that housed waiting rooms, restaurants, and administrative offices.

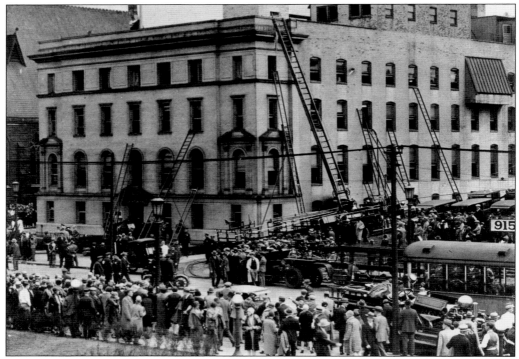

The stock market crash in 1929 rocked the world, but a major disaster involving the Cleveland Clinic ended the decade in a disaster for Cuyahoga County. It is thought that x-ray film exposed to heat from a 100-watt incandescent lightbulb that was not shielded discharged smoke and poisonous gas. Crowds formed quickly on May 15, 1929, to watch the rescue efforts.

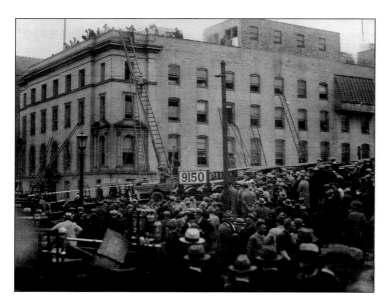

The building is viewed here from a different angle and depicts even more onlookers. The Cleveland Fire Department extinguished the fire, and its firefighters rescued many victims. The disaster would lead to the development of enhanced emergency planning in Cleveland, while nationwide new standards were established for the maintenance and identification of hazardous material.

Seven

AN ODD COUPLE OF DEPRESSION AND HOPE
1930–1939

The fall of 1929 saw the stock market crash, and the country seemed to collapse with it. Cuyahoga County would not be spared the economic woes of the Depression, as unemployment, homelessness, and poverty seemed everyday companions. But with federal dollars dedicated to solving the country's problems, the New Deal gave hope to a bleak era, bringing new housing, improvements to the infrastructure, and the development of recreational areas. Republicans would return to Cleveland in June 1936 to nominate Kansas governor Alfred Landon as its presidential candidate to face Franklin Delano Roosevelt, and the convention brought 13,000 visitors to the city.

Despite the suffering experienced by many, there were occasions for celebration. With the end of Prohibition, beer and its production returned to Cuyahoga County, and residents enjoyed viewing various sporting events, including football at the collegiate level. On the seamier side, however, gambling and criminal activities engaged the attention of Cleveland police, and the gruesome killings known as the "torso murders" struck fear into the hearts of the citizenry. Safety director Elliott Ness was never able to identify the serial killer responsible for these barbarities.

Toward the end of the decade, the Great Lakes Exposition held in Cleveland during 1936 and 1937 helped the city to mitigate the grimness of the Depression and celebrate its centennial as an incorporated city. However, storm clouds were gathering in Europe, and the world once again would be at war, and with it the county of Cuyahoga.

The stock market crashed in October 1929, and despite optimistic estimates that things would improve, the economy failed to rebound. Businesses nationwide were forced to close, and banks failed. The onset of the Great Depression also had an inevitable effect on Cuyahoga County, and it would be no surprise that hospitals, like Mount Sinai, would struggle to care for the crowd of free patients, as seen here, waiting for treatment.

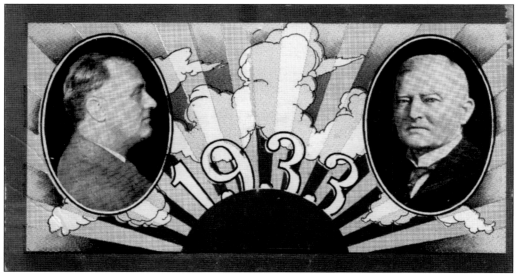

Despite the despair and poverty of the Depression era, the election of Franklin D. Roosevelt and John Nance Garner brought a ray of sunshine and hope to Clevelanders and a beleaguered American populace. The reverse side of this image is a ticket to the inauguration of Roosevelt and Garner, held in Washington, DC, on March 4, 1933. The $5 tax-exempt ticket provided admission to stand 9, section C, row 19, and seat 22. (Courtesy of Tim Daley.)

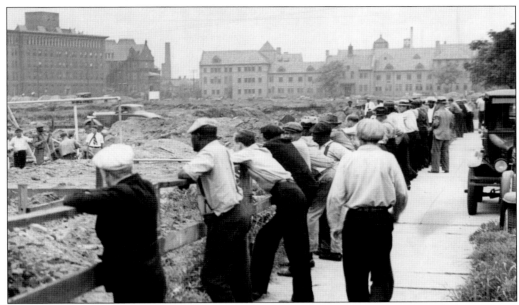

The need for better housing had been an issue in Cleveland for some time, but through the initiative of men like state senator and city councilman Ernest Bohn, plans to clear slums and provide decent housing percolated during the early 1930s. Under the New Deal, $150 million were appropriated for housing, and Cleveland was rewarded with the first three Public Works Administration projects. Men are seen watching as new homes are being constructed in the Cedar Central District.

This 1934 photograph offers a bird's-eye view of one of the slum areas lying between Cedar and Central Avenues and East Twenty-second and East Thirtieth Streets. Broken and shattered windows are visible on the house that dominates the photograph, and what appears to be garden space seems overgrown and unattended. But with federal funding, new construction would replace the deteriorating structures with new homes.

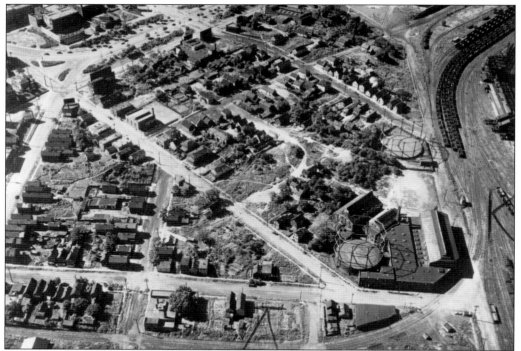

The need for improved housing and slum clearance was not limited to those areas east of the Cuyahoga River, as Cleveland's near west side would also benefit from government funds. This aerial view, taken in 1935, highlights the west side area that was to be cleared for one of the federal housing projects.

Closer to the ground, this view depicts the district from West Twenty-ninth Street and River Road as it appeared in 1935 just before the houses were torn down and replaced by more modern dwellings in the federal West Side Housing Development. The photograph is looking southeast from a slip landing to the Cuyahoga River.

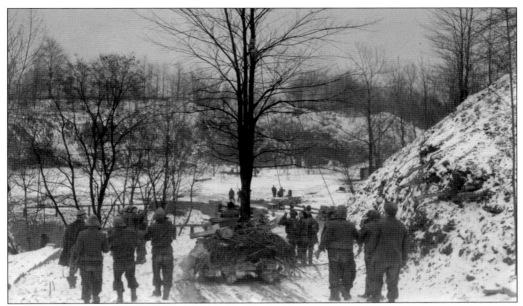

Federal dollars also assisted in the development of the metroparks during the 1930s. The Euclid Creek Reservation benefited greatly from the work of the Civilian Conservation Corps, as Company 595 camped for nearly a year on Highland Road. Rooted-up trees in the reservation were replanted so that they would flourish more readily to contribute to the park's beauty. Here corps members are moving an elm tree to a different area of the reservation.

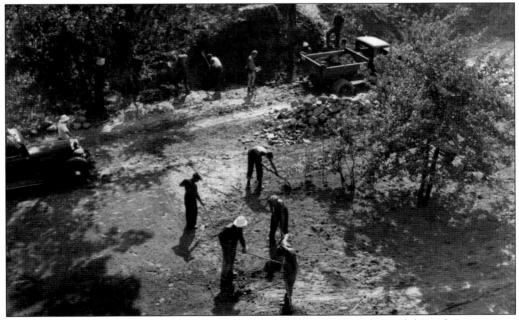

Several members of the Civilian Conservation Corps are observed in the Euclid Creek Reservation creating picnic grounds. The young men labor in the heat of the sun, as some wear hard hats, others caps, and one gentleman seen toward the back of the photograph has donned shorts, a cap, and boots.

Established in 1935, the Works Progress Administration (WPA) substituted work relief for direct relief to the unemployed. Most of the WPA projects involved conservation or public works, but some also offered job opportunities to individuals with talent in art, music, and theater, including writers who produced a helpful series of state guidebooks and records inventories. In this undated photograph, a group of WPA workers has convened in Cleveland's Public Hall for a convention. (Courtesy of the Cuyahoga County Archives and the Cuyahoga County Engineer's Office.)

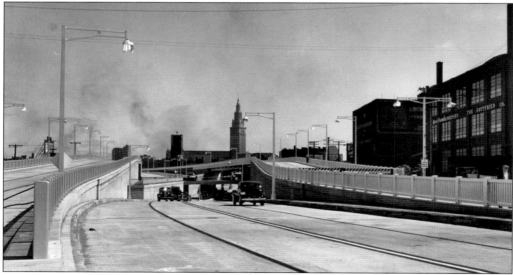

The Main Avenue Bridge opened in October 1939 after 17 months of construction with the financial support of Cuyahoga County and the Public Works Administration. The photograph views the bridge as it heads east toward downtown Cleveland. The Main Avenue Bridge connects the East and West Shoreways. (Courtesy of the Cuyahoga County Archives and the County Engineer's Office.)

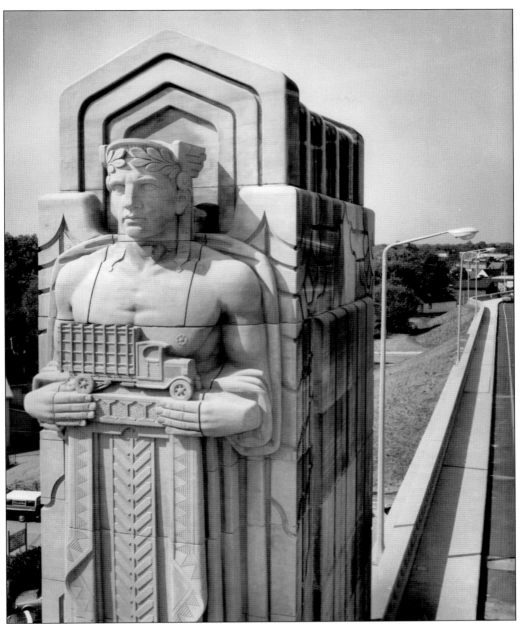

The Lorain Carnegie Bridge was the second of the significant high-level spans to traverse the Cuyahoga River. The steel and concrete bridge, almost a mile in length, was designed by Wilbur J. Watson and Associates with Frank Walker as a consulting engineer. Walker designed the four huge pylons, sculpted by Henry Hering, that serve as the span's most defining characteristic. The pylons hold eight figures that represent the guardians of traffic, and in this photograph a modern truck is featured. Architectural historians would describe the pylons as a link between stylized classicism and a Modernistic or Art Deco style. The Lorain Carnegie was renamed the Hope Memorial Bridge in honor of the family of comedian and actor Bob Hope, who were Cleveland stonemasons.

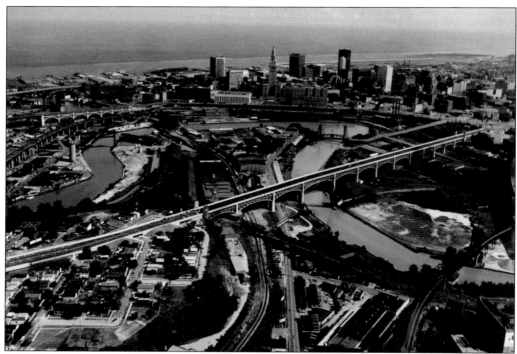

The Hope Memorial Bridge is a primary feature in this 1983 photograph, and from a distance the large pylons appear quite small in comparison to their actual size. In the distance, clouds hover over Lake Erie, while the Terminal Tower stands tall along Cleveland's skyline. This overview of the city was taken by the Cuyahoga County Engineer's Office under the direction of county engineer Thomas J. Neff. (Courtesy of the Cuyahoga County Archives and the Cuyahoga County Engineer's Office.)

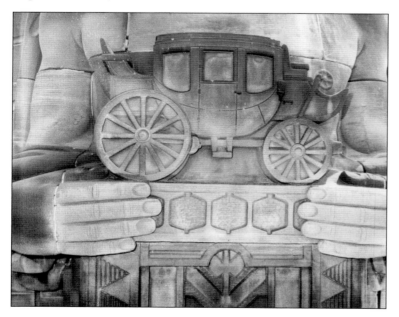

This close-up view of one of the stone pylons on the Lorain Carnegie/Hope Memorial Bridge shows another of the eight guardians of traffic. Appearing to almost rest on the massive hands of the pylon is a vehicle that represents an earlier form of conveyance, perhaps used by the county's 19th-century citizenry. (Courtesy of the Cuyahoga County Archives and the Cuyahoga County Engineer's Office.)

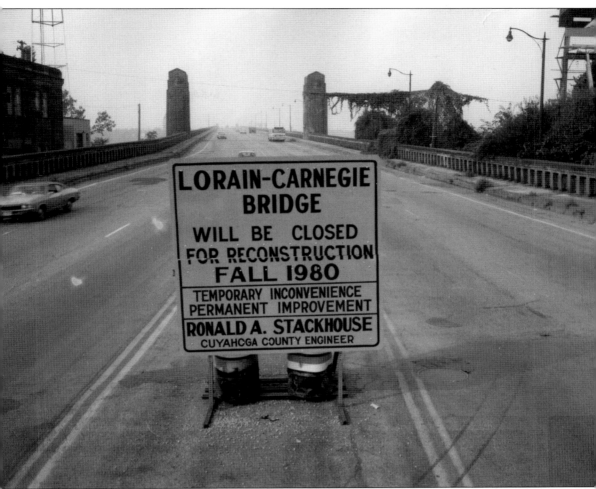

The Lorain Carnegie/Hope Memorial Bridge was closed for three years between 1980 and 1983 to replace its concrete roadway deck. The major repairs and renovations were necessary as chemical and waste discharge from the industrial flats caused pollution and erosion of the concrete. Visible in the photograph are the stone pylons, as well as a sign that identifies county engineer Ronald Stackhouse and offers the assurance that the closing of the bridge would be a temporary inconvenience but a permanent improvement. In 1935, the Ohio Legislature recalled the county surveyor's position to that of "county engineer." Candidates for the position were required to hold registration certificates as both a professional engineer and professional surveyor. Stackhouse, who held the office from 1977 to 1981, was the third person to serve as county engineer. He succeeded Albert S. Porter, who held the position from 1946 to 1977. (Courtesy of the Cuyahoga County Archives and the Cuyahoga County Engineer's Office.)

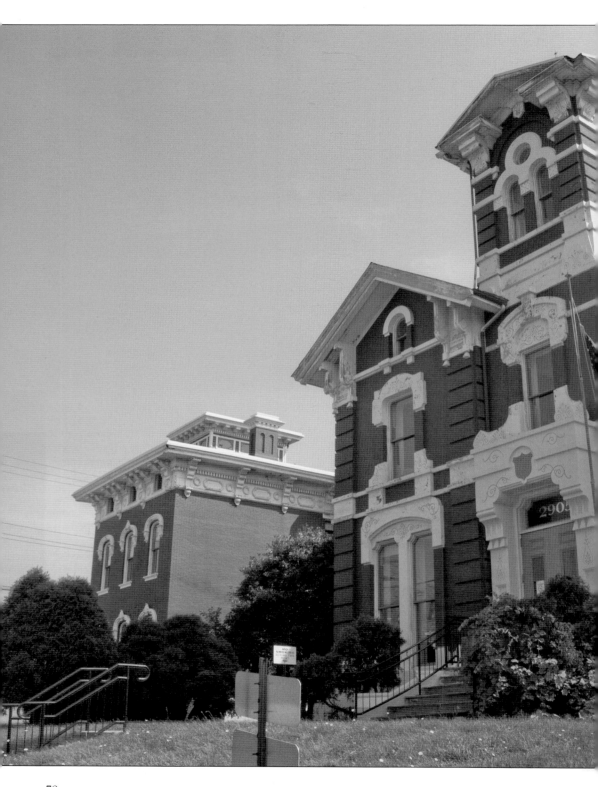

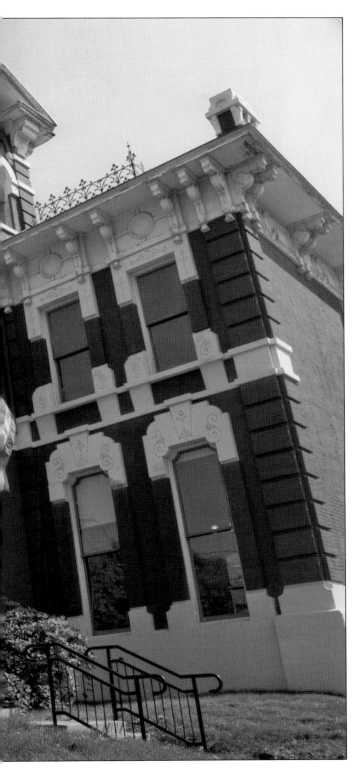

This Victorian Italianate structure at 2905 Franklin Boulevard, once a private dwelling built in 1874, is known as the Robert Russell Rhodes House after its original owner and has housed Cuyahoga County Offices and Agencies since about 1917. It served as the Detention Home and was later the site for the first Cuyahoga County Nursing Home, beginning in 1938. The nursing home opened as an experimental shelter for relief patients who were permanently and totally disabled. The Rhodes House was later occupied by the Board of Mental Health and Retardation as a school for youngsters with various challenges. This building on Franklin Boulevard has been home to the Cuyahoga County Archives since 1978 and is a repository for Cuyahoga County's records and a research and reference library for the study and review of the documents in its holdings.

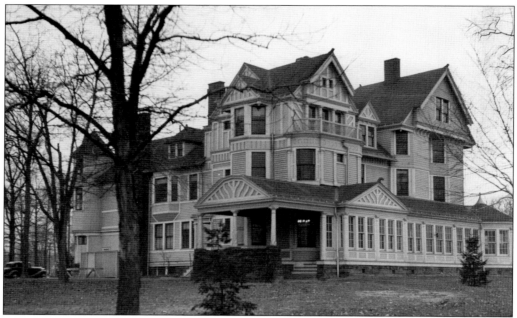

Robert Russell Rhodes, brother of historian James Ford Rhodes and brother-in-law of Sen. Marcus Hanna, moved from his residence on Franklin Boulevard with his wife, Kate Castle Rhodes, to a home built around 1880 in Lakewood. Located at the corner of Belle and Lake Avenues, the three-story dwelling was purchased by the City of Lakewood in 1918 for use as a temporary city hall.

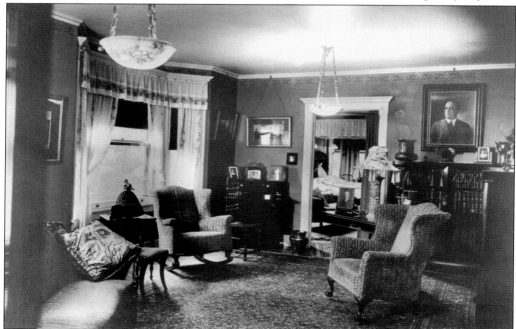

This interior view from the Rhodes House in Lakewood shows the second-floor living room with a peak into the master bedroom adjoining it. The home not only served as a city hall but also accommodated the overflow of patients from Lakewood Hospital during the influenza epidemic of 1918.

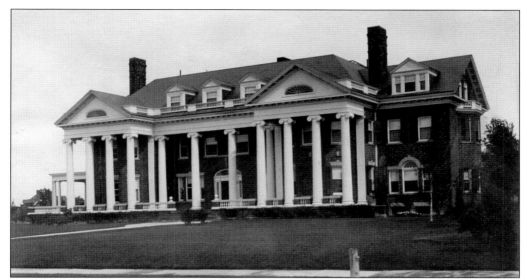

Large and stately homes were not only common in areas on the county's west side but could also be seen in Cleveland's eastern suburbs. The Colonial-style home of William L. Rice, a prominent attorney, was built about 1900 on Overlook Road in the city of Cleveland Heights. On August 5, 1910, Rice was shot, stabbed, and bludgeoned to death in Cleveland Heights. Rice's murder was never solved.

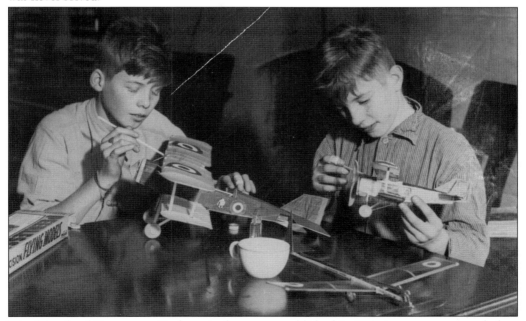

The Cleveland Protestant Orphan Asylum was established in 1852 in response to a cholera epidemic that left children homeless. The first institution was located at East Fifty-fifth Street and Woodland Avenue but would eventually move to a new location in Pepper Pike, Ohio, in 1926. As more orphans were being placed in foster homes by the mid-1930s, the institution, later to be known as Beech Brook, began accepting troubled children from dysfunctional families. But these boys seem content working on a model airplane in 1938.

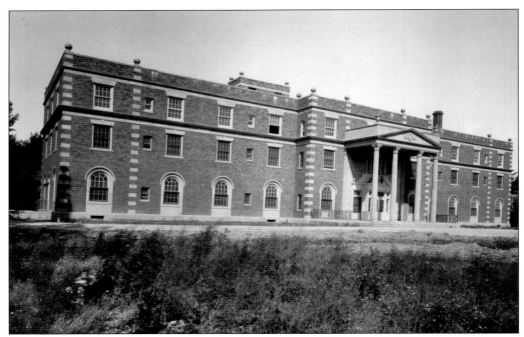

During the early years of the Depression, another institution, the Cunningham Sanitarium located on Lakeshore Boulevard at East 185th Street, ministered to the needs of those suffering from various diseases, most particularly diabetes. The hallway in the Administration Building was said to run from the extreme right of the building to the doorway that led to the tanks and sphere.

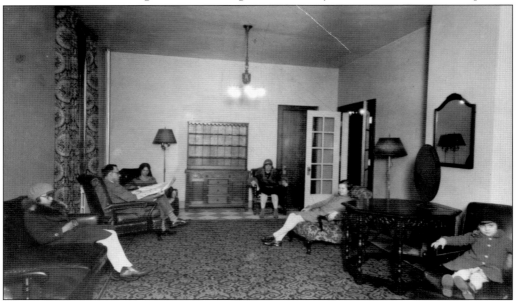

The treatment administered at the sanitarium was developed by Dr. Orval J. Cunningham of the University of Kansas and was based on a belief in the beneficial effects of oxygen therapy. It is not clear whether those seated are awaiting therapy or planning to visit family members who were patients at the sanitarium

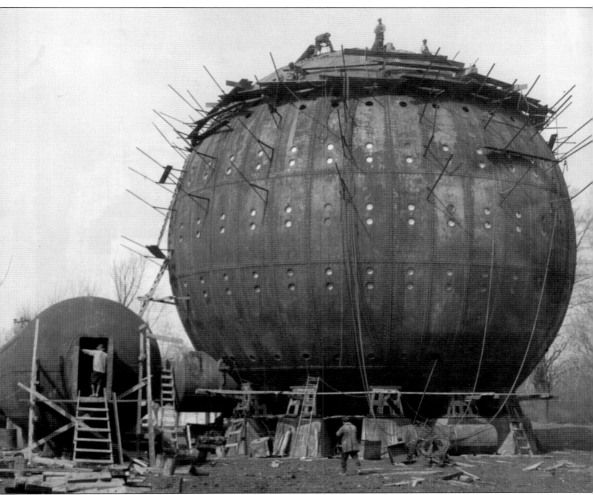

This five-story spherical steel structure was created to provide a pressurized atmosphere for the treatment of disease. The building of the Cunningham Sanitarium was championed by H.H. Timken, owner of the Timken Roller Bearing Company in Canton, Ohio, who was motivated by a friend who was treated successfully by Dr. Cunningham. The structure seen here weighed 900 tons and contained 38 rooms and over 300 portholes. The ball was connected to a three-story sanitarium hotel by a series of steel tanks. Those taking the air cure could comfortably eat, sleep, or read in the pressurized tanks. The sanitarium was sold and served as the Ohio Institute for Oxygen Therapy and later was known as Boulevard Hospital. The Roman Catholic Diocese of Cleveland purchased the site in 1937. When the sanitarium was razed in 1942, the scrap steel was contributed to the war effort.

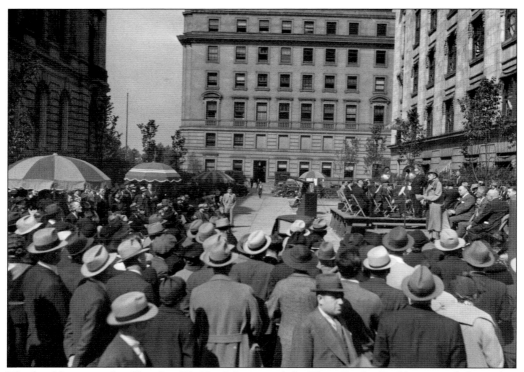

The land between the Cleveland Public Library and the Plain Dealer Building was dedicated as Eastman Park on September 30, 1937, honoring Linda A. Eastman, who established the park as an area for reading and relaxation. In this photograph, Eastman is seen standing on the platform with a crowd gathered to participate in the dedication ceremony.

Here patrons are seated under shade umbrellas reading in the Eastman Park during the late 1930s. The Cleveland Public Library first opened in February 1869 in rented quarters on the southwest quadrant of the Public Square. Luther M. Oviatt was the first librarian, and Linda Anne Eastman, for whom the park is named, held the position as the fourth librarian.

The constitutional amendment ending Prohibition was ratified in December 1932, and beer was soon flowing throughout the nation. But when Cleveland brewers announced that their beer would not be suitably aged prior to May 1933, speedy action proved necessary. In this April 1933 photograph, beer provided by the Atlas Brewing Company in Chicago is being unloaded at Cleveland's Airport from an American Airways flight. (Courtesy of the Associated Press.)

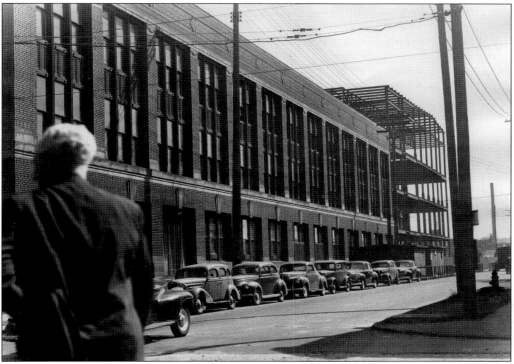

The Carling Brewing Company was first incorporated as the Brewing Corporation of America and started operations in 1933. Company owner James A. Bohannan, also president of Peerless Motor Cars, proposed to his stockholders that the Peerless plant, less than profitable at selling luxury cars during the Depression, be transformed into a brewery. Opened in 1934, the Brewing Corporation is seen here at its location on 9400 Quincy Avenue.

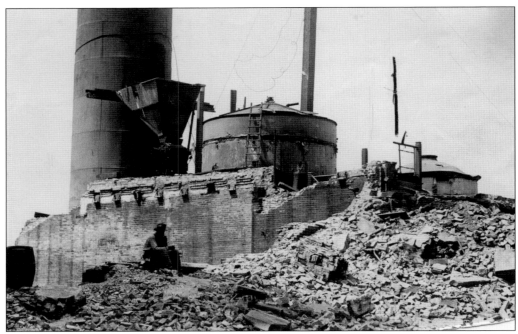

A combination of Prohibition and the construction of Union Terminal contributed to the sorry end of Diebolt Brewing Company's $3 million plant located on Pittsburgh Avenue, SE, at the corner of East Twenty-seventh Street. The Van Sweringens found it profitable to purchase the Diebolt land for their approach to the terminal. Diebolt had been a small family-operated brewery until it closed in 1928.

The Pilsener Brewing Company, seen here in 1915, was located at the southwest corner of Clark Avenue and West Sixty-fifth Street and produced distinct beers, including POC, or Pilsener of Cleveland. During Prohibition, Pilsener turned to the production of low-alcohol beers, soft drinks, fruit juices, and dairy products, but by the spring of 1933 it was back in the beer business.

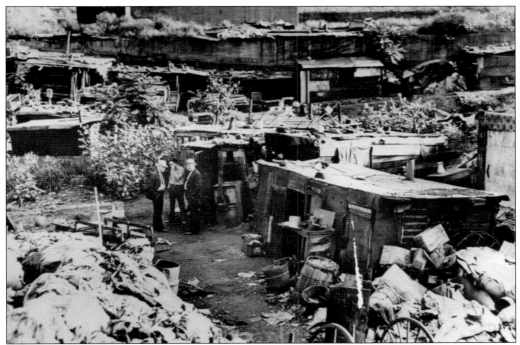

This unhappy view shows the hobo camp near downtown Cleveland, which was where many of the victims of the torso murderer were thought to have lived. Safety director Elliott Ness would eventually order the destruction of all the shantytowns by burning them to the ground. Despite the efforts of detective Peter Merylo, who was assigned the full-time duty of pursuing the killer and the arrest of 1,015 suspects, the "Mad Butcher of Kingsbury Run" was never found. (Courtesy of the Associated Press.)

The discovery of the bones of the 12th and 13th victims of the torso murderer attracted a curious crowd who observed officials combing the lakefront for additional body parts. The dignitaries observed coroner Samuel R. Gerber, detective James Hogan, and deputy police inspector Charles O. Nevel digging at the site.

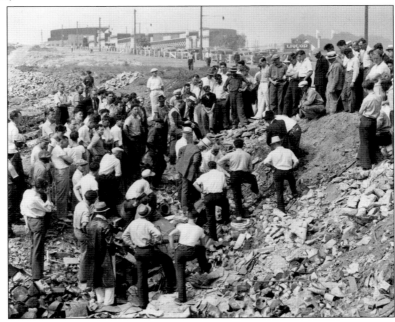

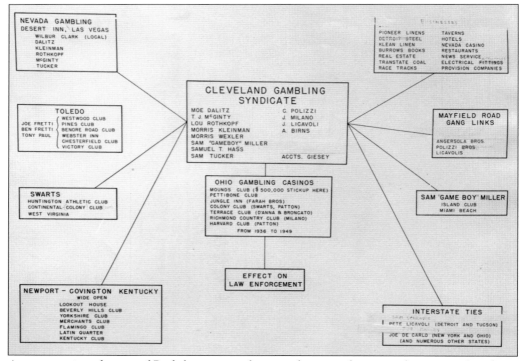

NEVADA GAMBLING
DESERT INN, LAS VEGAS
WILBUR CLARK (LOCAL)
DALITZ
KLEINMAN
ROTHKOPF
McGINTY
TUCKER

BUSINESSES
PIONEER LINENS TAVERNS
DETROIT STEEL HOTELS
KLEAN LINEN NEVADA CASINO
BURROWS BOOKS RESTAURANTS
REAL ESTATE NEWS SERVICE
TRANSTATE COAL ELECTRICAL FITTINGS
RACE TRACKS PROVISION COMPANIES

CLEVELAND GAMBLING SYNDICATE
MOE DALITZ C. POLIZZI
T. J. McGINTY J. MILANO
LOU ROTHKOPF J. LICAVOLI
MORRIS KLEINMAN A. BIRNS
MORRIS WEXLER
SAM "GAMEBOY" MILLER
SAMUEL T. HASS
SAM TUCKER ACCTS. GIESEY

TOLEDO
JOE FRETTI WESTWOOD CLUB
BEN FRETTI PINES CLUB
TONY PAUL BENORE ROAD CLUB
 WEBSTER INN
 CHESTERFIELD CLUB
 VICTORY CLUB

MAYFIELD ROAD GANG LINKS
ANGERSOLA BROS.
POLIZZI BROS.
LICAVOLIS

SWARTS
HUNTINGTON ATHLETIC CLUB
CONTINENTAL COLONY CLUB
WEST VIRGINIA

OHIO GAMBLING CASINOS
MOUNDS CLUB ($ 500,000 STICKUP HERE)
PETTIBONE CLUB
JUNGLE INN (FARAH BROS)
COLONY CLUB (SWARTS, PATTON)
TERRACE CLUB (D'ANNA & BRONCATO)
RICHMOND COUNTRY CLUB (MILANO)
HARVARD CLUB (PATTON)
FROM 1936 TO 1949

SAM "GAME BOY" MILLER
ISLAND CLUB
MIAMI BEACH

EFFECT ON LAW ENFORCEMENT

NEWPORT - COVINGTON KENTUCKY
WIDE OPEN
LOOKOUT HOUSE
BEVERLY HILLS CLUB
YORKSHIRE CLUB
MERCHANTS CLUB
FLAMINGO CLUB
LATIN QUARTER
KENTUCKY CLUB

INTERSTATE TIES
SAM SCHRADER
PETE LICAVOLI (DETROIT AND TUCSON)
JOE DE CARLO (NEW YORK AND OHIO)
(AND NUMEROUS OTHER STATES)

Accompanying the era of Prohibition was the introduction of organized crime to Cuyahoga County, including bootlegging and the rackets. However, crime did not end with Prohibition, and this schematic illustrates the connection between the Cleveland Gambling Syndicate and others throughout the United States. The chart was placed as evidence before the Senate Special Committee to Investigate Crime in Interstate Commerce, which was chaired by Sen. Estes Kefauver.

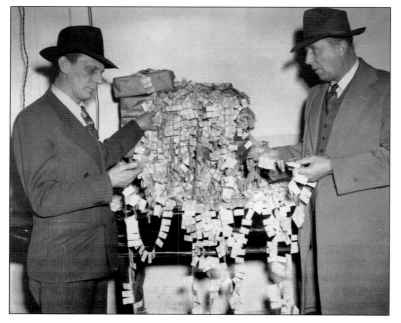

Gambling in the poorer neighborhoods of Cleveland often involved illegal lotteries, known as the numbers game or policy racket. In this photograph, a patrolman from Cleveland (left) and a detective lieutenant from Cleveland Heights inspect thousands of lottery tickets linked together by what appears to be string.

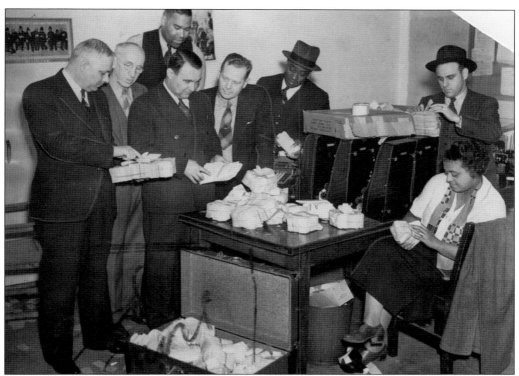

A search for criminals indicted in a policy racket resulted in the discovery of policy slips totaling $10,000 in bets made at the Rockside Club in Independence, which was thought to be headquarters for the criminal activity. The photograph reveals multiple adding machines used to tabulate the returns and shows police officer Virginia Huston examining the slips. Also seen reviewing the slips are two police detectives and an assistant county prosecutor among others.

Gambling was not limited to illegal lotteries but involved gaming machines as well. In 1941, these law enforcement officers look on after gambling machines, seized in the morning raids, were put out of circulation and placed under padlock. Local police agencies had been waging war against gambling since January 1924, when they began confiscating the slot machines.

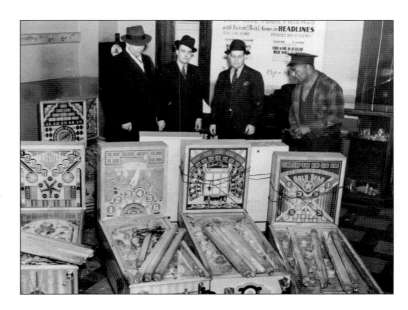

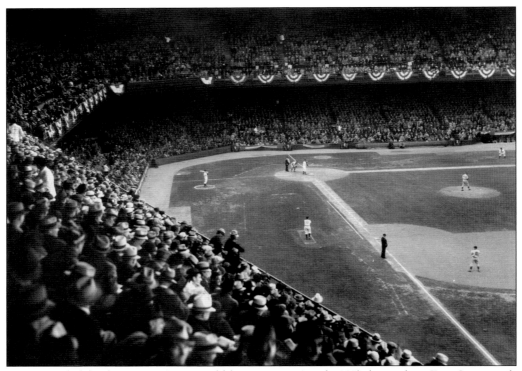

League Park (also known as Dunn Field between 1916 and 1927), located on East Sixty-sixth Street and Lexington Avenue, opened on May 1, 1891. Cleveland's professional baseball team, known as the Cleveland Indians since 1915, defeated the Brooklyn Dodgers to win the 1920 World Series at League Park. The team continued to use the venue until 1947, when the Indians moved to Cleveland Municipal Stadium. In this view, 21,000 fans are in the stands at League Park for opening day in April 1935.

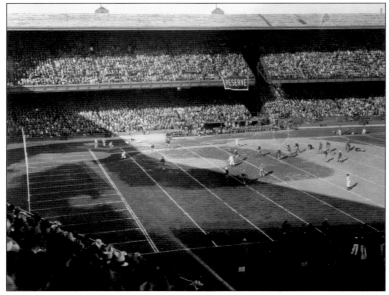

Amateur football on the college level was held in high regard by county residents during the 1920s and 1930s. Four teams, Western Reserve, Case, John Carroll, and Baldwin Wallace, remained consistently active. In November 1935, League Park was packed with fans for the big game between Western Reserve and Baldwin Wallace.

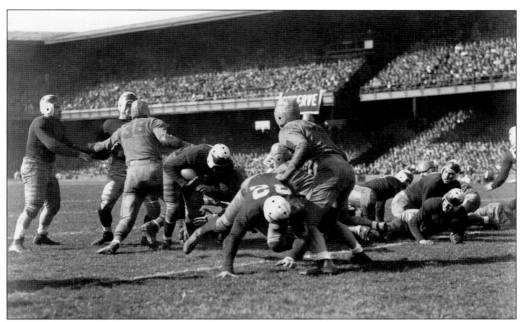

Here is a close-up of the action on the gridiron, as a capacity crowd watches the November 1935 game. Western Reserve and Baldwin Wallace, as well as Case and John Carroll, had strong football programs that were viewed as a positive way to attract attention, students, and financial contributions to the respective schools.

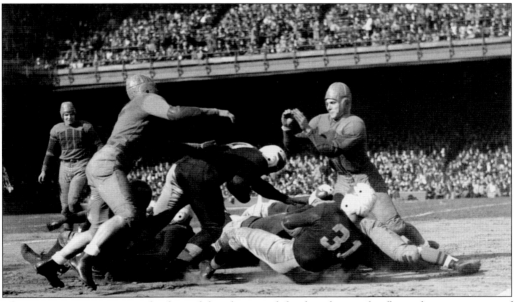

The intense expression on the face of the player with his hands raised reflects the importance of these rivalry games to the students at Western Reserve and Baldwin Wallace. The final score on this November day was a close one, as Reserve defeated Baldwin Wallace 21 to 14. After World War II, it became increasingly difficult for private colleges to compete for talent and support their programs in an era of big-time college football.

The Republican National Convention returned to Cleveland in 1936 to elect its candidates for president and vice president. Part of the fanfare included a marching group of Uncle Sams from Buffalo, New York, moving east on Euclid Avenue from Public Square. Visible behind the marching Sams is the Soldiers and Sailors Monument.

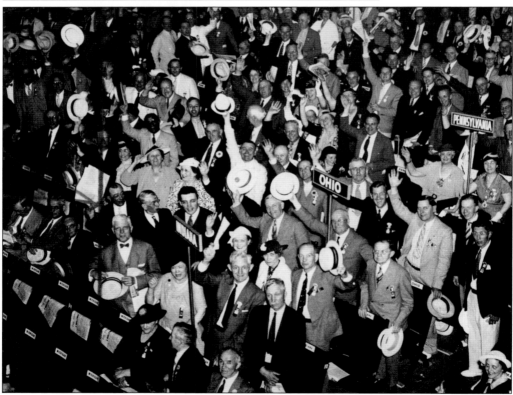

Cleveland's Public Hall hosted the Republican National Convention and was renovated to accommodate the equipment and wiring for radio broadcast of the proceedings. The convention opened June 9, 1936, and the Ohio delegation with hats off cheer as Oregon senator Frederick Stiewer, the keynote speaker, describes for the audience the "American Deal." On the second day of the convention, Herbert Hoover would address the assembly.

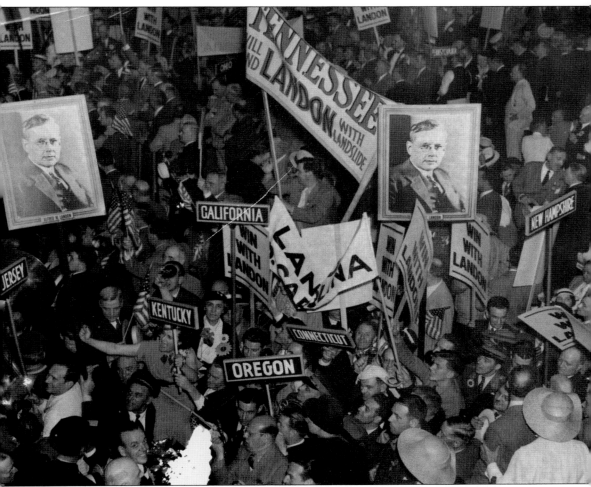

The Republicans came to Cleveland with a platform that vowed to maintain relief and accelerate employment but wanted relief efforts to be returned to nonpolitical local agencies. Gov. Alfred Landon of Kansas was the convention's choice for president and was nominated on the first ballot. On that June 11, 1936, enthusiastic delegates seen in the photograph are displaying various flags, banners, and state standards, and their spontaneous demonstration forced a long delay in the nominating speech given by John Hamilton. The delegates ran out into the aisles and shouted and cheered for the governor from Kansas. Landon never came to Cleveland but remained at home, although he maintained telephone contact with his followers. On June 12, the delegates selected Col. Frank Knox from Illinois as the vice presidential candidate. The convention brought 13,000 visitors to the city that included 1,001 delegates and alternates in company with campaign workers and reporters.

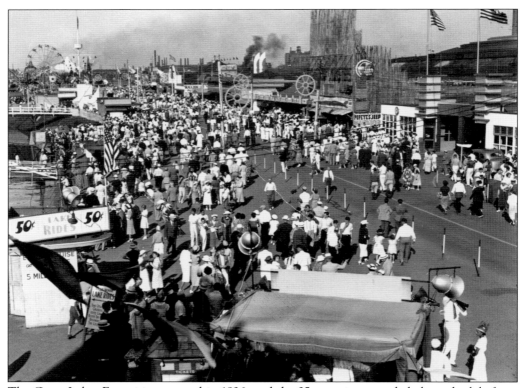

The Great Lakes Exposition opened in 1936, and the 35-acre site extended along the lakefront from West Third Street to about East Twentieth Street. It opened on June 27 and was extended for a run in 1937 as well. Over seven million people visited the exhibition over two years and spent over $7 million. Hundreds of individuals in summer dress are seen in this photograph exploring the exposition's midway area.

From left to right, lovely ladies Lois Stately, Betty Sherman, Noel Arden, and Zuzzana are seen examining some unmentionables as they prepare for their jobs in the exposition's French Casino.

Here all of the French Casino girls are seen posing on the exhibition's opening day on June 27. In addition to the casino, other attractions at the exhibition included the Streets of the World, where cafés and bazaars reflected the countries they represented; a Hall of Progress; an Automotive Building; and horticultural gardens.

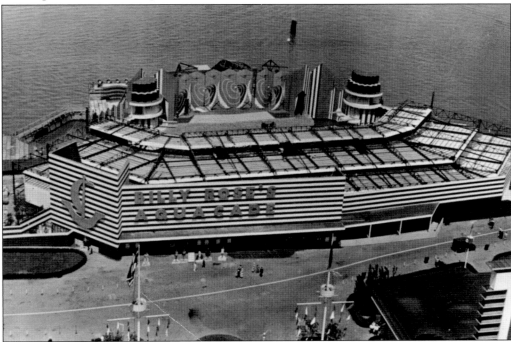

The hit of the 1937 exhibition season was Billy Rose's Aquacade, which was a music, dance, and swimming show that starred Eleanor Holm and Johnny Weismuller. Rose was a theater showman and lyricist who wrote or collaborated in the writing of many popular songs, as well as a Broadway producer and owner of theaters and nightclubs. The Aquacade also appeared at the 1939 World's Fair in New York.

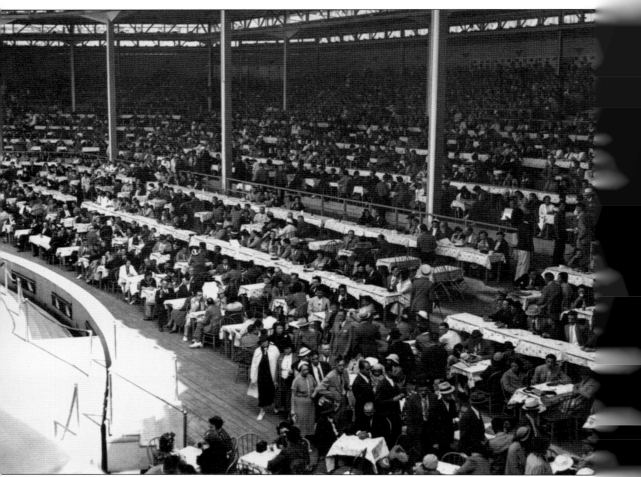

This interior view of the marine theater shows rows of tables on lower and higher levels. The stage for the Aquacade performances was located in Lake Erie, about 60 feet offshore, while the audience could view the show from a 4,000-seat casino. After the performance, the stage would move in so that visitors could step onto the floor and dance to well-known bands. One of the groups performing at the Aquacade was the Bob Crosby Orchestra. Stars Eleanor Holms and Johnny Weismuller were both Olympic champion swimmers; Weissmuller is perhaps best known for his portrayal of Tarzan on the silver screen. After divorcing his wife, Fanny Brice, Billy Rose married Eleanor Holms. The Aquacade would later appear at the 1939 World's Fair in New York, where it was judged the most successful production at the event. An amphitheater with a capacity of 11,000 was built by architects Sloan and Robertson for the fair.

Eight

ENTERING A NEW AGE
1940 TO THE PRESENT

World War I was called the war to end all wars, but the rise of dictators like Hitler and Mussolini and the militarism of the Japanese made that pronouncement false. World War II was fought on the home front as well as in the European and Pacific theaters of action. Cuyahoga County formed a civilian defense council to coordinate activities for protection against air raids and sabotage, and citizens became involved in guaranteeing the safety of their communities. County residents' solidarity with those fighting overseas was also evidenced by public displays of support. During World War II, the Lakeside Hospital Unit continued the example it set in the World War I and became the first American hospital to set up operations in the South Pacific. In the midst of warfare, the East Ohio Gas Explosion would also cause havoc on Cleveland's east side.

The end of the war in August 1945 was celebrated by Cuyahoga County, as many flocked to downtown Cleveland and expressed their joy with festivities that rivaled those in Times Square. As the world returned to some semblance of normalcy, the county enjoyed the simple pleasures during the years after the war. The county fair drew a large attendance annually, and folks watched parades and celebrated festivals in their home communities. Local businesses and industries also thrived. Yet Cuyahoga County would not remain immune from matters affecting the entire nation, and the issues of civil rights and the war in Vietnam would impact its citizens during the 1960s. But the heart of rock 'n' roll, filled with energy and initiative, would beat throughout the county in the new millennium, which fueled hope for an ongoing transformation of the community in the years to come.

The attack on Pearl Harbor on December 7, 1941, quickly found a response in Cleveland, and the Cuyahoga County Civilian Defense Council was established to serve as the area's civilian defense organization. This photograph features members of the group's executive committee, including the mayors or city managers of Cleveland, East Cleveland, Euclid, Lakewood, and Parma. Missing from the photograph are county commissioner Joseph Gorman and Cleveland Heights mayor Frank Cain.

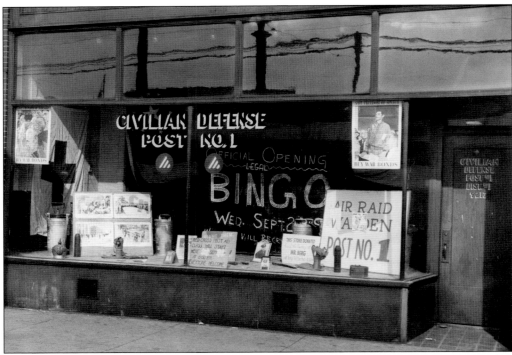

This storefront brought civilian defense to the neighborhood level; the signs visible in the window tell their own story about war-time activities. Posters encourage the purchase of war bonds, a Red Cross first-aid class is touted as open to the public at that location, and photographs of men in uniform are on display. Although somewhat puzzling, an ad for the official opening of legal bingo also appears on the window.

This bevy of beauties, known as the Warner Brothers' "Navy Blues" sextet, has purchased US postage stamps dedicated to the war effort at their local post office. The young women are, from left to right, Peggy Diggins, Marguerite Chapman, Kay Aldridge, Georgia Carroll, Lorraine Gettman, and Claire James. Photographs like this must have encouraged Clevelanders to follow suit by purchasing bonds and stamps for their country.

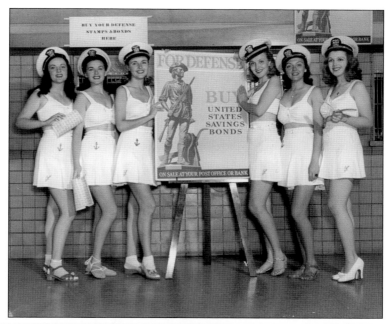

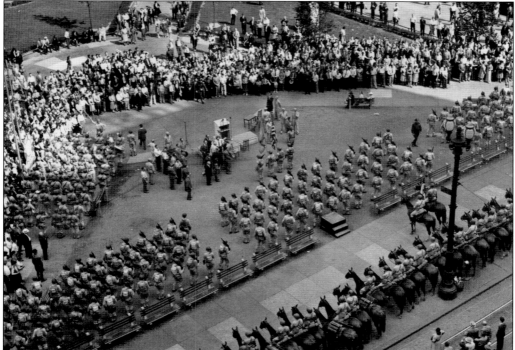

The Armed Forces Army War Show, held in 1942, was fully embraced by Cleveland mayor Frank J. Lausche. He pledged not only to support those units of the provisional task force participating in the war show but to continue supporting those same units when they begin fighting for "keeps." The war show was held in Cleveland Municipal Stadium, but the photograph shows its official welcome on Cleveland's Public Square.

The Lakeside Hospital Unit returned to wartime service by representing the first US hospital to initiate operations in the southwest Pacific. By 1944, the unit had cared for 40,000 American fighting men. In 1917, Dr. George W. Crile led the Lakeside Unit into France with the first US troops. The women seen here serving with the unit are, from left to right, Capt. Ann C. Deeds, Capt. Betty Boyer, Maj. Olga C. Benderoff of Cleveland Heights, and Lt. Ruth Kinzler.

A group of Cleveland physicians from the Lakeside Hospital Unit are seen examining a Japanese sword that Lt. Col. McGaw planned to take back home with him. Pictured from left to right in the first row are Maj. Ralph Cox, Lt. Col. Wilbert H. McGaw, Col. William C. McCally, and Maj. I.C. Hanger. Most of the physicians were either from Cleveland Heights, East Cleveland, Shaker Heights, or South Euclid.

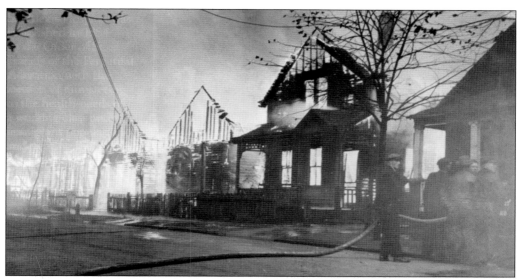

While death and destruction might have been expected overseas, Clevelanders in 1944 did not expect a major conflagration in their own backyard. On a Friday afternoon in October, an East Ohio Gas Company tank holding liquid natural gas exploded and devastated an east-side neighborhood bounded by St. Clair Avenue, NE, East Fifty-fifth Street, East Sixty-seventh Street, and the Memorial Shoreway. The houses in this photograph appear like skeletal remains against a smoke-filled sky.

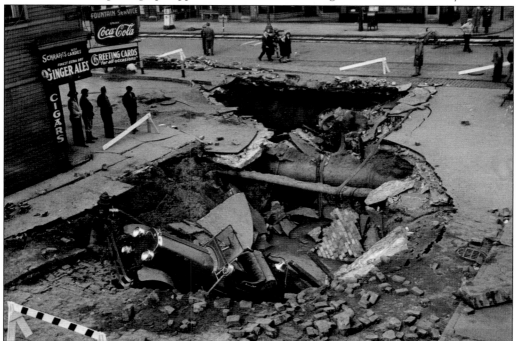

In addition to the effects of the disastrous fire, vaporizing gas traveled along curbs, gutters, and catch basins and then entered the sewer system. Occasional explosions tore up pavement and blew out manhole covers. Such a blast certainly caused the huge crater that swallowed up this automobile. A total of over 200 cars were destroyed.

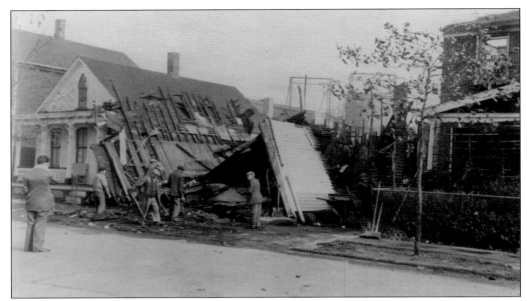

The fire that spread over multiple blocks consumed entire rows of houses while skipping others. In this view, one home has been reduced to rubble, while surrounding houses appear to have escaped the fire's wrath relatively unscathed. Initial reports recorded that some 3,600 people were made homeless by the blaze.

Safety forces stand guard at the perimeter of one of the devastated areas. In addition to the loss of homes and vehicles, the number of deaths resulting from the disaster was 130. Within a day or two of the explosion, electricity was restored to certain areas, and some residents were able to return home. From all accounts, this was the worst fire in the city's history.

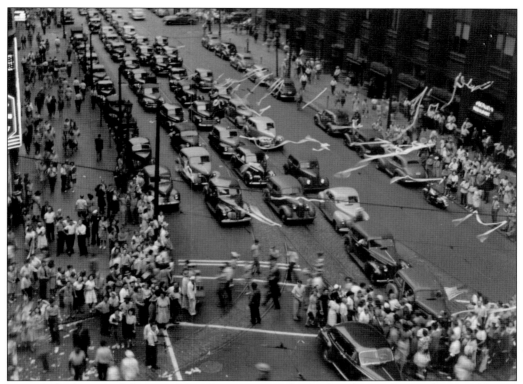

Despite the horror of the East Ohio Gas Company fire and explosion, happy days would soon return to Cuyahoga County. The war in Europe ended in May 1945, and victory over Japan was announced on August 15. On that day, a huge victory parade, lasting more than three hours, moved down Superior Avenue, as confetti floated over the automobiles in the procession. The delirious celebration attracted more than 300,000 county residents.

Victory celebrations were not limited to the downtown area of Cleveland as shown by the happy youngsters gathered at West 105th Street and West Boulevard. The boys and girls proudly waved flags and played musical instruments to express their excitement over the war's end. Most of the children appeared to come on foot, but at least one arrived with a bicycle.

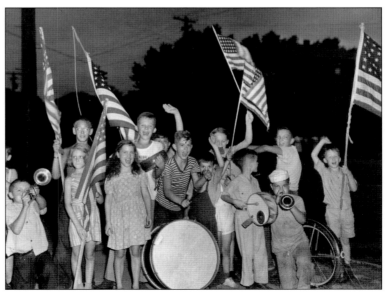

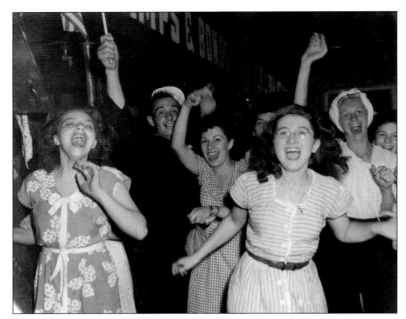

Not all Clevelanders joined in the victory parade on Superior Avenue, and this group of young adults whooped and hollered outside the Stillman Theater on Euclid Avenue. A sailor waves the American flag, while others simply wave their hands in the air. One woman was so excited, she arrived with curlers in her hair.

The Cleveland War Memorial Fountain stands as a representation of the city's respect for those who served during World War II. The memorial was dedicated on May 30, 1964, and stands on Mall Avenue. The figure at the memorial's center is representative of man rising from the flames of war and lifting skyward as a sign of eternal peace. Bronze plates inscribed with the names of those who perished in World War II and Korea are on the surface of the rim that surrounds the fountain. (Courtesy of Rose Costanzo.)

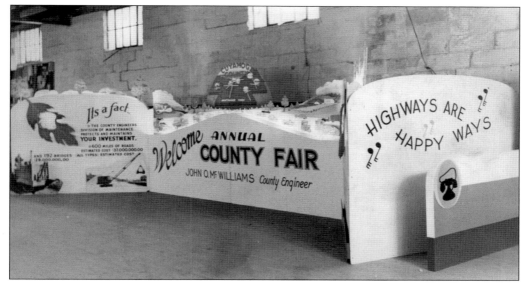

During the postwar years, county residents found community in enjoying the simpler pleasures. The Cuyahoga County Fair, for example, has been a summer staple in Berea since 1893. This display for the fair, prepared by the Cuyahoga County Engineer's Office, reminded county residents that this department's maintenance division protected their investment by preserving 600 miles of areas roads and 92 bridges at a cost of over $60 million. (Courtesy of the Cuyahoga County Archives and the County Engineer's Office.)

On March 17, everyone in Cuyahoga County is Irish, as the annual St. Patrick's Day Parade is held in downtown Cleveland. The city is awash with green, and revelers watch marching units and floats. Some people start the day by first attending Mass and then enjoying a hearty breakfast. Here Pipefitters Union No. 120 members wish everyone a happy St. Patrick's Day. (Courtesy of Rose Costanzo.)

While St. Patrick's Day holds the promise of spring, the Italian community celebrates Columbus Day in early Fall. On a cold and damp day, many watch members of the Knights of Columbus march down Mayfield Road in Cleveland's Little Italy neighborhood in commemoration of the discovery of America by Christopher Columbus. (Courtesy of Rose Costanzo.)

Organized support of women's suffrage began in earnest in Cleveland early in the 20th century, and the Cleveland Suffrage League lobbied intensely for the vote in Ohio. Despite their efforts, success was not obtained until the passage of the 19th amendment, granting women the right to vote. The hard work of the suffragettes is remembered by another generation of women for the Parade of Progress in 1952.

The International Children's Games (ICG) are a sanctioned event of the International Olympic Committee for those 12 to 15 years of age. Metod Klemenc, a Slovenian sports instructor, established the games in 1968 with the goal of promoting peace and friendship to the world's youth through sports. Klemenc organized the first International Children's Games and Cultural Festival held in Slovenia, and the games involved teams from nine Europeans towns and cities. (Courtesy of Rose Costanzo.)

Cleveland hosted the ICG from July 29 to August 2, 2004, and the event would welcome over 3,000 coaches and athletes to the area. Youth from many nations, as reflected by the flags in the background, gathered for this photograph. David Gilbert, president and CEO of the Greater Cleveland Sports Commission, looked upon the games as a "true global village" where competition would thrive and virtues like tolerance and fairness would live. (Courtesy of Rose Costanzo.)

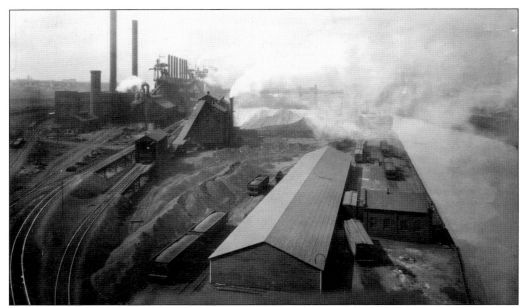

Cleveland's reputation as a steel producer continued during the postwar years. The Corrigan-McKinney Steel Co., once regarded as one of the nation's outstanding steel companies, was a pig iron and steel producer with its plant strategically located on the Cuyahoga River. Republic Steel purchased Corrigan-McKinney in 1935. This photograph shows the Corrigan-McKinney steel mill in 1926.

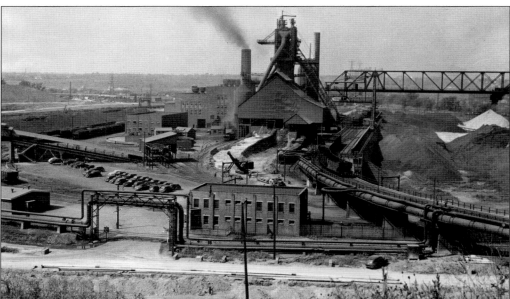

Republic Steel, with its headquarters in Cleveland, was rated the fifth-largest steel producer in 1984. Formed in 1930, the company rose to the position of third-largest steel maker in the nation. Hit by the Depression, Republic Steel purchased the Corrigan-McKinney Co. to stabilize its business and later moved corporate headquarters from Youngstown to Cleveland. This 1948 photograph shows the Kaiser Frazer blast furnace at the Republic Steel plant.

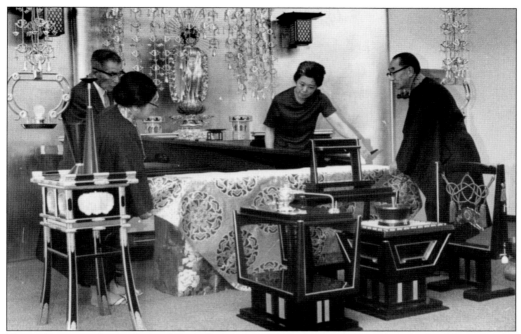

New religious traditions helped form the county's identity after World War II. The Chinese, who arrived in significant numbers after the turn of the 20th century, and the Japanese, who came to the area following the end of World War II, were often followers of Buddhism. Here a new altar received from Japan, for use in the Cleveland Buddhist Temple at East 214th Street and Euclid Avenue, is being installed.

Muslims first arrived in Greater Cleveland in the 1920s, and their numbers grew gradually and experienced a noted increase during the 1960s. The Muslim community is ethnically diverse, with practitioners from the Middle East, North Africa, parts of India, and Indonesia. Many African Americans are Muslim as well. There are several mosques in the area, and shown here is the First Cleveland Mosque on Union Avenue.

The Morman Church has deep roots in northeast Ohio, particularly in Kirtland in Lake County, although branches of the Latter Day Saints were established in Mayfield Village, Orange, Strongsville, and Warrensville in Cuyahoga County during the 1830s. In 1946, one Latter Day Saints branch encompassed most of northeast Ohio, with members assembling in space rented in the Carter Hotel in Cleveland, as seen here. This class of adults is being instructed by Morris Wright.

Smaller communities of faith also gathered to practice their religious beliefs. Seen in this Chagrin Falls home one evening in 1971, adherents of Nichiren Shochu, a Japanese tradition and way of life, have met for a prayer session. Chanting was an important tenet of the faith and could last from 30 minutes to as much as two hours depending on the nature of the service.

Christianity was not only observed in traditional church buildings but could be practiced in storefronts like this one. As he leans against a parking meter, the Reverend Iverson Pauley stands before the Full Gospel Jesus Church on Broadway Avenue. From information about the photograph, it seems that snake handling was an element of the worship in this community.

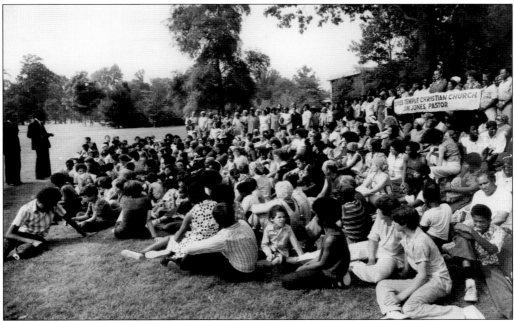

In 1976, the Peoples Temple visited Cleveland as part of a bus tour of the United States in celebration of the nation's bicentennial. Here followers are gathered for a service, in happier times, at Wade Park. The members of the Peoples Temple met their tragic end in an area known as Jonestown in Guyana. Under the direction of Rev. Jim Jones, members of the community took their lives by consuming grape Flavor-Aid laced with cyanide.

Cuyahoga County residents awoke to the news one July morning in 1954 that Marilyn Reese Sheppard, wife of Dr. Sam Sheppard and mother of one son, had been brutally slain in her home in Bay Village, a close-knit residential community west of Cleveland. Sam, an osteopathic physician at Bay View Hospital on Lake Road, insisted his wife's murderer was a bushy-haired intruder. But the doctor was eventually charged with the murder of his wife and high school sweetheart as Cleveland newspapers called for Sheppard's arrest, insisting that his family was part of a cover-up for the crime. A nine-week trial ended with jury's verdict of second-degree murder on December 21, 1954, and Sheppard was sentenced to life in prison. But an aura of mystery would continue to shroud the death of this young woman, as people to this day continue to debate the guilt or innocence of Dr. Sheppard. (Courtesy of Rose Costanzo.)

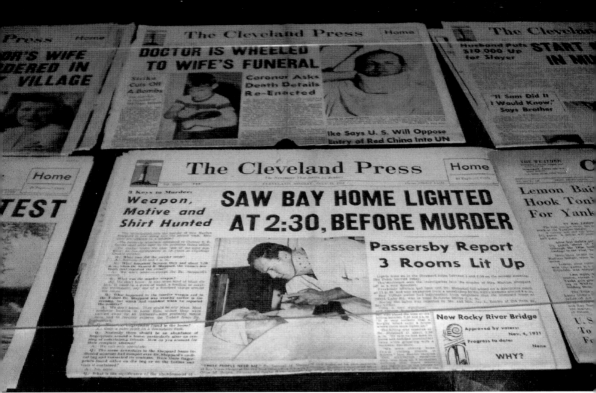

This display of headlines from the *Cleveland Press* mirrors the media's intense scrutiny of every detail in the Sheppard murder case. In fact, the antagonistic coverage launched by the *Cleveland Press* and the paper's demands that public officials charge Sheppard with the crime eventually led to a Supreme Court ruling that pre-trial publicity had been harmful to the accused and resulted in a new trial. Sheppard was acquitted on November 16, 1966.

To Albert Porter –
with warm regards.
Lyndon B. Johnson

In office from 1963 to 1968, Pres. Lyndon Baines Johnson ushered in the Great Society, and during his first year in office Congress passed many significant bills, including the Civil Rights Act and anti-poverty legislation. Ironically, the early 1960s would be characterized by the existence of painful poverty amid prosperity and the gradual end to discrimination while racial tensions increased. Here President Johnson is seen with Cuyahoga County engineer Albert Porter at the White House. (Courtesy of the Cuyahoga County Archives and the Cuyahoga County Engineer's Office.)

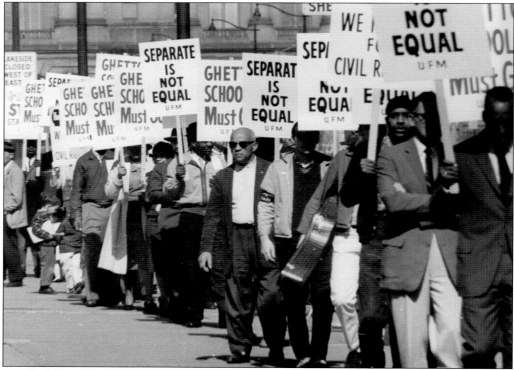

People from all walks of life, including mothers and toddlers, councilman and judges, and notables like child care expert Dr. Benjamin Spock and Congress of Racial Equality member Eric J. Reinthaler, picketed the Cleveland Board of Education in September 1963 alleging de facto segregation of African Americans in Cleveland schools. The protesters were organized under the United Freedom Movement.

In the shadow of Terminal Tower and under the watchful gaze of Abraham Lincoln, marchers continue to carry picket signs before the Board of Education Building protesting segregation of African Americans in Cleveland Public Schools. The protesters were organized under the United Freedom Movement. The organization, initially comprised of African American women, was successful in uniting other civil rights organizations in Cleveland to oppose school segregation.

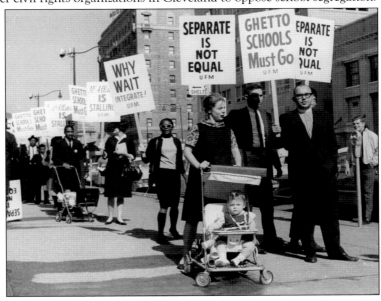

Mrs. David K. Cohen, a 27-year-old Cleveland Heights mother, and her 11-month-old daughter join the picketers at the board of education on a warm September afternoon; not far behind the young mom, a man is seen pushing a child in a stroller. Parents looking to the future education of their children carry signs declaring separate is not equal and ghetto schools must go.

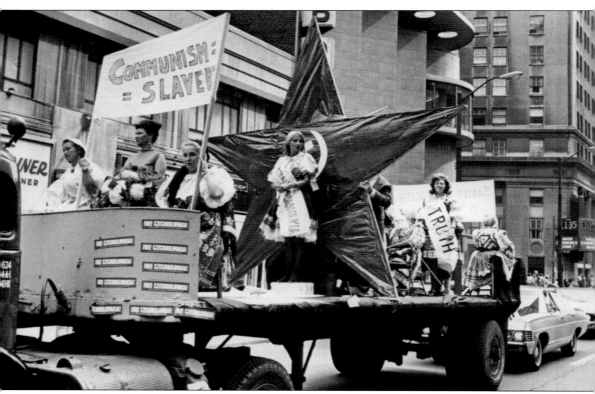

An era known as the Prague Spring arrived in Czechoslovakia in January 1968, when Slovak leader Alexander Dubcek came to power and ushered in a period of political liberalization. Western media used the image of a Prague Spring to denote a thaw after the "winter" of the Cold War. In April 1968, Dubcek introduced a program of sweeping reforms that included autonomy for Slovakia and a revised constitution that guaranteed civil rights and liberties. This "spring" did not survive the summer of 1968, as the Soviet Union and its Warsaw Pact Allies, with the exception of Romania, invaded the nation with troops and tanks to end the reforms. There was not any military resistance, although many non-violent protests were held. New leadership would rescind most of the reforms instituted by Dubcek. Here, on a flatbed truck traveling on Euclid Avenue, women in traditional Czech dress hold a sign proclaiming that Communism equaled slavery.

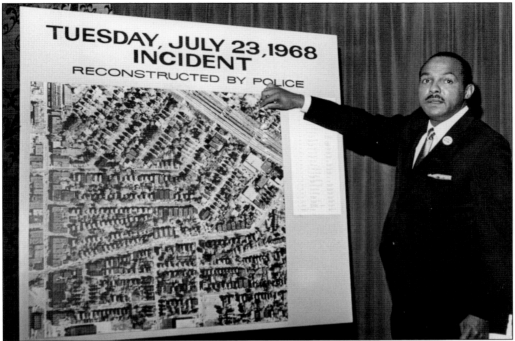

Violence erupted in Glenville on the evening of July 23, 1968, which involved a confrontation between the Cleveland Police Department and a group of black militants. Mayor Carl Stokes decided that African Americans could best bring peace to the area, and initially, only black leaders and police were allowed in Glenville. The mayor also requested the assistance of the National Guard to quell the disorders. Stokes is shown here with a police reconstruction of the July 23 incident.

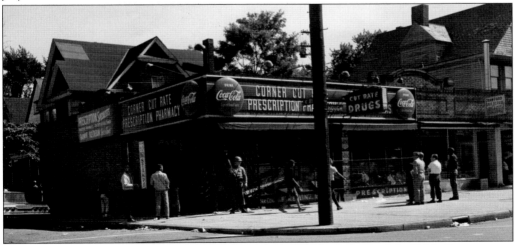

Two years earlier, violence engulfed the Hough neighborhood during July 1966. Spontaneous rioting, characterized by vandalism, looting, arson, and some gunfire, became serious and appeared to be precipitated by a conflict over a glass of water at a café on Hough Avenue and East Seventy-ninth Street. In the photograph, a small group of bystanders has gathered in front of a Cut Rate Drugstore, while a National Guardsman stands on duty to prevent further unrest.

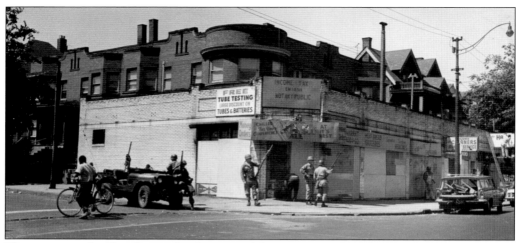

The rioting in the Hough area that began on July 18 continued on the evening of July 19, 1966, and Mayor Ralph Locher called in the National Guard to restore order and closed all of the bars and taverns. The Guard's presence is clearly established in this photograph outside of a commercial building in the Hough neighborhood.

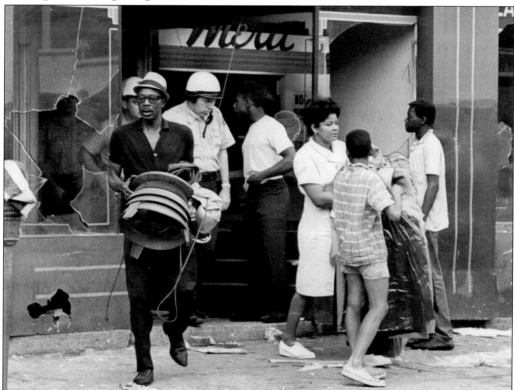

Looting was a part of the unrest in Hough, and in this photograph police appear to stand by while a man removes a fan and others carry off clothing. The human toll of these riots included four dead and 30 injured, while multiple arrests were made. These events in Cleveland's Hough neighborhood seemed to grow out of racial tension and frustration experienced throughout the country in 1966.

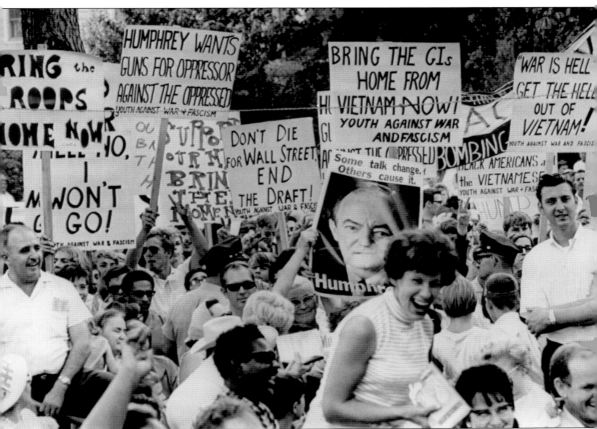

The 1960s represented a volatile era, and protests over civil rights were joined by discontent over the war in Vietnam. Cleveland was host to several anti-war conferences, and a strong anti-war sentiment grew on otherwise peaceful college campuses like Case Western Reserve University. This was particularly true after the US invasion of Cambodia and the deaths of students at Kent State University. During the presidential campaign in 1968, Democratic candidate Vice President Hubert Humphrey spoke at Euclid Beach Park in September 1968. Humphrey was met by some supporters but also faced criticism from a vocal group of anti-war protesters who heckled the vice president as he spoke to the assembled gathering of about 10,000 persons. The signs visible displayed the range of sentiments that called for bringing the GIs home from Vietnam to ending the draft, although one poster with Humphrey's image suggested he was the candidate that could create change. Humphrey would lose the November election to Richard Nixon.

Battles in the jungles of Vietnam and crossfire on city streets could not entirely dim the allure of confrontation on the gridiron or bats and balls on the diamond. Cleveland Municipal Stadium had hosted these games of skill and thrills for the entertainment of the county's avid sports fans since the 1930s. The stadium had also served as a venue for diverse events, ranging from rock concerts to religious revivals. In 1994, the Cleveland Indians moved to a new field at the corner of Carnegie Avenue and Ontario Street, and at the end of 1995 Art Modell, owner of the Cleveland Browns, took his team to Baltimore. So in 1996, the stadium was razed to be replaced by a new football arena as the home of the new Cleveland Browns. The loss of the stadium was bittersweet, and at its closing many fans took home artifacts that would remind them of the venue that had provided so much excitement over the years. As its seats lie empty and deserted, a shadow is cast on the interior of the stadium. (Courtesy of Rose Costanzo.)

When Cleveland Municipal Stadium opened in 1931, it had a capacity of over 78,000 seats, and in July of that year a championship boxing match between Max Schmeling and Young Stribling was held there. The Indians played their first game at the stadium in 1932, and the "Dog Pound" was alive in the 1980s, as avid fans cheered on the Browns in the stadium. (Courtesy of Rose Costanzo.)

Cuyahoga County and its residents have always had a love affair with its sports teams. In 1995 and 1997, the Cleveland Indians, then playing at Jacobs Field, went to the World Series, only to lose to the Atlanta Braves and the Florida Marlins, respectively. The formidable lineup stands with its back to the camera and includes, from left to right, Wayne Kirby, Julio Franco, Carlos Baerga, Albert Belle, Eddie Murray, Jim Thome, Manny Ramirez, Tony Peña, and Omar Vizquel. (Courtesy of Rose Costanzo.)

The world appeared to end for Browns fans in 1995, when Browns owner Art Modell announced his decision to take the team to Baltimore, Maryland. Negotiations between the National Football League (NFL), the Browns, and representatives from Baltimore and Cleveland created a settlement that called for the team to be deactivated for three years but promised a new stadium where a new Browns team would resume play in 1999. The Browns would also be permitted to retain the name, brown and orange colors, history, awards, and archives. In turn, Modell was given a new franchise in Baltimore and the contracts of all of the current players and personnel. The old Browns would become the Baltimore Ravens. This float appeared in the 1999 St. Patrick's Day Parade announcing that 157 days remained until the first Browns game, which was scheduled for August 21, 1999. In 1998, it had been decided that the new Browns would be an expansion team rather than moving a team from another location. (Courtesy of Rose Costanzo.)

Cleveland is often considered the heart of rock 'n' roll and owes its origins to Leo Mintz, owner of Records Rendezvous, and disc jockey Alan Freed. The two helped to promote rhythm-and-blues records, dubbing the music rock 'n' roll. Although the headliners at this January 1967 concert are unidentified, the teens in attendance appear enthusiastic about the band as a policeman stands by to ensure order is kept.

Here an older and mellower crowd congregates for a rock festival held in July 1971. Although the particulars of this festival cannot be discerned, it was not an unusual activity for the time, as it had been preceded by musical events on a much larger scale like Woodstock in 1969 and the Monterey International Pop Music Festival in Monterey, California, held in 1967.

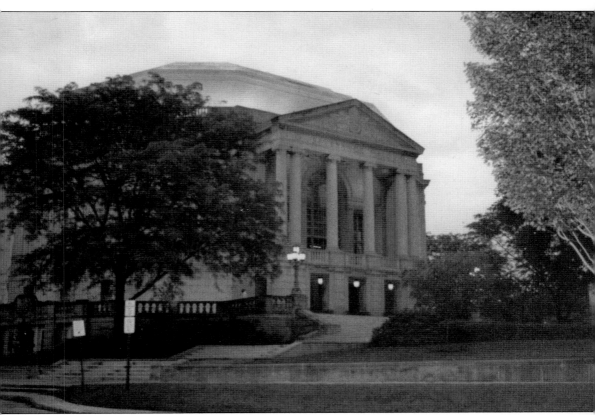

Cuyahoga County not only pays musical homage to Elvis at the Rock and Roll Hall of Fame, but it also keeps alive the symphonies of Mozart and Schubert through the performances in Severance Hall by the renowned Cleveland Orchestra. This concert hall, located in Cleveland's University Circle area, was completed in 1930–1931 and funded by philanthropist John Long Severance, who dedicated this remarkable edifice to his recently deceased wife, Elizabeth DeWitt Severance. (Courtesy of Rose Costanzo.)

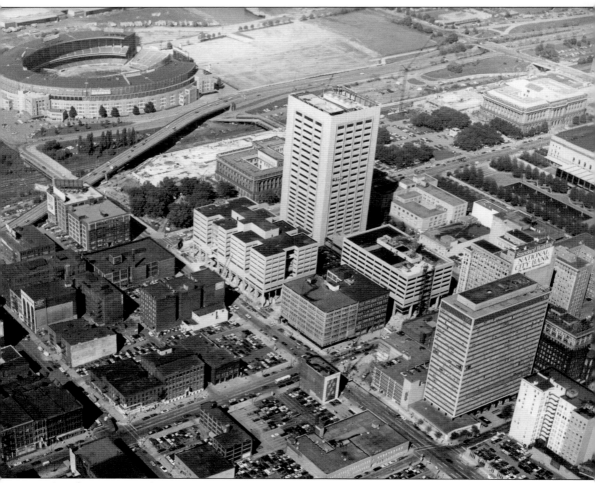

Cuyahoga County has grown from humble origins in a temporary courthouse on Public Square to a modern urban community that continues to evolve with plans for a new Medical Mart and convention center. In this photograph, the county's Justice Center towers over the landscape. The center was completed in 1977 and houses the prosecutor's office, the common pleas and municipal courts, police headquarters, and a corrections center. On the north side of Lakeside Avenue, across from the Justice Center and partially hidden by its 26-story tower, is the fifth Cuyahoga County Courthouse, completed in 1912. The architectural firm of Lehman and Schmitt designed it, while Charles Schweinfurth was largely responsible for the interior spaces. Also on the north side of Lakeside and east of the county courthouse is Cleveland City Hall. Joining the courthouse as part of the city's Group Plan, city hall was completed in 1916 and designed by J. Milton Dyer. Finally, to the north of the county courthouse is the new Cleveland Browns Stadium, which has been in use since 1999. (Cuyahoga County Archives and the Cuyahoga County Engineer's Office.)

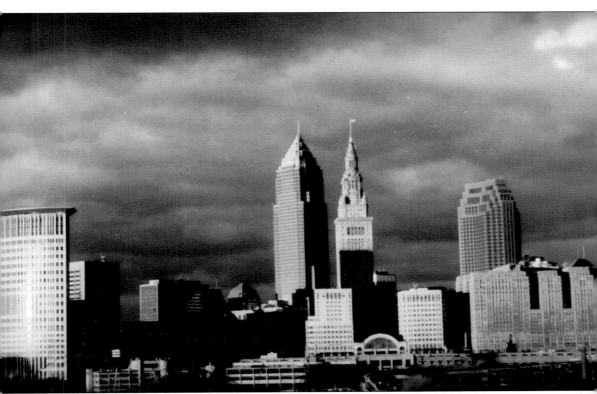

This view of Cleveland's impressive skyline includes the Terminal Tower, an edifice readily identifiable as the city's most recognized landmark. The 708-foot tower was completed in 1927, and until 1967 it was considered the tallest structure in the world outside of buildings in New York City. The erecting of Cleveland Union Terminal and Terminal Tower represented the largest construction project for the city during the 1920s, and Oris P. and Mantis J. Van Sweringen developed the complex on Public Square. Also visible is the 57-story Key Tower, a skyscraper completed in 1991 that is the tallest structure in Cleveland and the state of Ohio. Until 2007, Key Tower remained the tallest building between Chicago and New York City. This photograph also includes the third-highest skyscraper in the city of Cleveland. Commonly referred to as the BP Building, the structure was originally intended to exceed the Terminal Tower in height, but objections were raised that the landmark tower should retain its status as the city's tallest building. (Courtesy of Rose Costanzo.)

www.arcadiapublishing.com

Discover books about the town where you grew up, the cities where your friends and families live, the town where your parents met, or even that retirement spot you've been dreaming about. Our Web site provides history lovers with exclusive deals, advanced notification about new titles, e-mail alerts of author events, and much more.

Arcadia Publishing, the leading local history publisher in the United States, is committed to making history accessible and meaningful through publishing books that celebrate and preserve the heritage of America's people and places. Consistent with our mission to preserve history on a local level, this book was printed in South Carolina on American-made paper and manufactured entirely in the United States.

This book carries the accredited Forest Stewardship Council (FSC) label and is printed on 100 percent FSC-certified paper. Products carrying the FSC label are independently certified to assure consumers that they come from forests that are managed to meet the social, economic, and ecological needs of present and future generations.

FSC
Mixed Sources
Product group from well-managed
forests and other controlled sources

Cert no. SW-COC-001530
www.fsc.org
© 1996 Forest Stewardship Council

Find Your Place in History.